IMAGES
of America

THE BAY BRIDGE

Paul C. Trimble and John C. Alioto Jr.

ARCADIA

Published by Arcadia Publishing
Charleston SC, Chicago IL, Portsmouth NH, San Francisco CA

Printed in Great Britain

Library of Congress Catalog Card Number: 2004117010

For all general information contact Arcadia Publishing at:
Telephone 843-853-2070
Fax 843-853-0044
E-mail sales@arcadiapublishing.com
For customer service and orders:
Toll-Free 1-888-313-2665

Visit us on the internet at http://www.arcadiapublishing.com

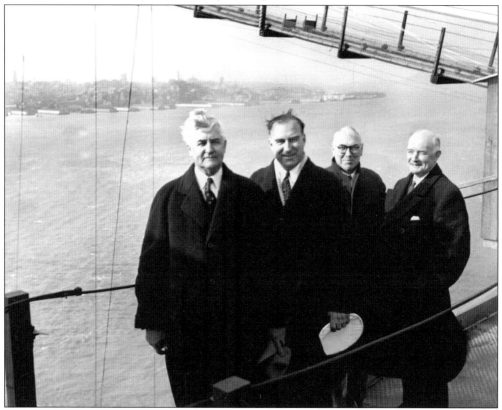

Pictured here, from left to right, are: Jesse H. Jones, Reconstruction Finance Corporation; Earl Lee Kelly, state director of Public Works; Charles Henry Purcell, chief engineer; and Leland W. Cutler, vice president, Financial Advisory Commission. These were the men who made it happen, once the necessary state legislation was enacted, and they had every reason to be proud of their efforts in this grand project. (Toll Bridge Authority, Alioto collection.)

CONTENTS

ACKNOWLEDGMENTS

The State of California Toll Bridge Authority fortunately contracted with professional studios to create a photographic history of the construction of the Bay Bridge. Many of those photos have come into the possession of the authors and make up the bulk of this volume. Effort has been made to give proper credit for each photo, and any omissions are regretted.

To Debbie, Kathleen, and Mike, for all you have given me.
—P.C.T.

To Brittany, my only child. Bless you for all your love and understanding. Stay strong.
—J.C.A. Jr.

INTRODUCTION

On August 5, 1776, Frigate Lieutenant Juan Manuel de Ayala of the Spanish Royal Navy, in recent command of His Most Catholic Majesty's schooner *San Carlos*, sailed into San Francisco Bay to begin the first definitively recorded European exploration of what was described by Fr. Juan Crespí as "a harbor such that not only the navy of our most Catholic Majesty but those of all Europe could shelter in it. [*sic*]"

The bay covers 400 square miles, contains 2 trillion gallons of saltwater, and is of such magnitude that for the next 161 years the only way to travel from the east shore of the bay to San Francisco was either make the laborious land trek south to San Jose and then north up the west side, employ whatever seaworthy vessel one could find available, or ride a ferryboat—often owned by a connecting railroad.

Regular ferry crossings between Oakland and San Francisco began in 1852 and 80 years later were still making the crossings, annually carrying 5 million automobiles and more than 6 times that number in foot passengers. And yet there was a public demand for an even better service than what the picturesque bay steamers had to offer.

It wasn't that the ferries were either unsafe, too expensive, or inefficient. Indeed, the ratio of lives lost in ferry accidents to the thousands of crossings with millions of passengers over the years showed them to be incredibly safe. The State Railroad Commission routinely regulated fares in the public's favor, and the ferries' efficiency was attested by the thousands of daily and weekend transbay travelers who rode the electric interurban and mainline steam trains of seven different companies that connected to the ferries with old-style railroad precision. Moreover, there was the Key System's network of local streetcar services in Alameda and Contra Costa Counties on the east shore and the numerous streetcar and cable car lines on the San Francisco side to whisk people to where they needed and wanted to go. So why bother to build such an extraordinarily expensive bridge at all? First, there was the dream. In 1872 San Francisco's Emperor Norton issued an imperial rescript to build such a bridge, but that was an act of either the city's most notorious crackpot or its most successful mountebank, so the bridge remained just an idea.

By the 1930s, however, a series of factors created a favorable climate for at last spanning the bay from Oakland to San Francisco. First, Henry Ford had transformed the automobile from a plaything of the rich into an affordable means of transport for working-class America before 1920. California, along with the rest of America, had entered the automobile age, but cars can't swim. Secondly, the populations of San Francisco and Oakland had grown large enough to

establish a potential revenue base for tolls to finance bonds to pay for the bridge's construction. Thirdly, by the 1930s the privately owned interurban trains and ferries were money losers. In fact, 1926 was the last year in which electric street railways and interurbans, as an industry, would be profitable. The growth of auto-carrying ferries on the bay had already cut deeply into the revenues of the electric railways and passenger ferries, and thus plans for the bridge began in the 1920s. Two more factors were the engineering technology that was available and America's immersion into the Great Depression. Simply put, the country was out of work and the economy was at near rock bottom. Massive expenditures on public works would help to provide employment, which the private sector was unable to do. Lastly, there was the American spirit of "can do," the same "can do" that built the transcontinental railroads, dug the Panama Canal, and decades later would have astronauts landing on the moon.

It was as if the sun, moon, planets, and stars had all reached their proper juxtaposition for the mightiest bridge in the world—the San Francisco–Oakland Bay Bridge—to at last be constructed.

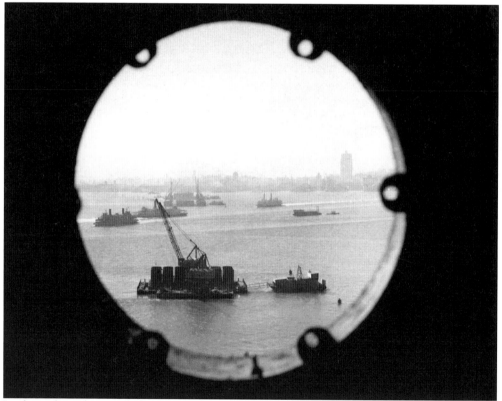

Looking through a porthole, the viewer is treated to a scene never to appear again as a trio of ferryboats cross San Francisco Bay amidst barges carrying heavy-duty equipment for constructing the San Francisco–Oakland Bay Bridge. (Courtesy of Standard Oil Company of California, Alioto collection.)

One

PUBLIC TRANSIT BEFORE
THE BRIDGE

East Bay, the region defined as Contra Costa and Alameda Counties, had its public transit genesis in 1863 with steam trains running on Oakland's city streets before horsecars, cable cars, and electric streetcars appeared. As pastureland yielded to development, public transit led the way, culminating in three electric interurban companies by 1913. Public transit on the west side of the bay has already been covered in a previous Arcadia publication about San Francisco's railways by the same author.

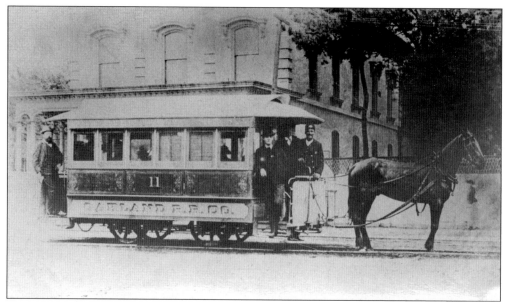

Incorporated in 1864, the Oakland Railroad Company operated a horsecar line to not only develop pastureland, but to provide civic transport as well. The line began operations in 1869 with a 10¢ fare, or 16 rides for a $1. (Trimble collection.)

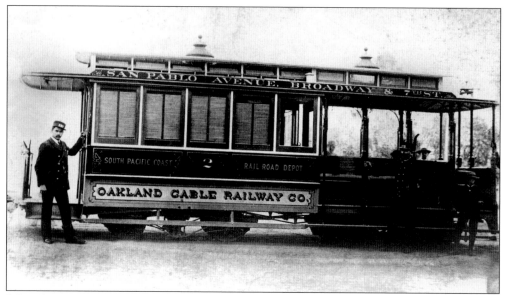

Silver King James G. Fair built the Oakland Cable Railway with service beginning November 19, 1886. In the early 1890s the line became part of the Oakland Railroad, eventually becoming part of the No. 2 streetcar line on Broadway and San Pablo Avenue. (Trimble collection.)

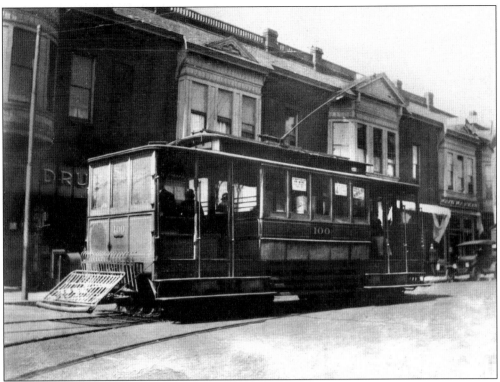

The Oakland Transit Company was formed in 1898 as a merger of six independent street railways serving East Bay cities. Here Oakland Transit Company No. 100 is seen at Shattuck and University Avenues in Berkeley. (Trimble collection.)

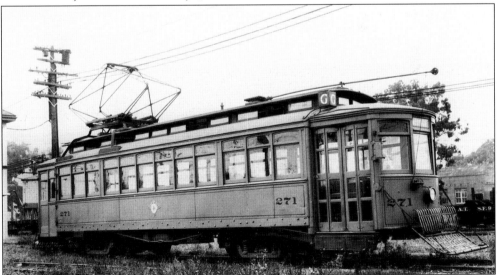

In 1902 Francis M. Smith began consolidating the street railways in Alameda County into a network of local streetcar lines to support his Key Route, which ran interurban trains to meet with Key Route ferries to San Francisco. Shown here is No. 271 on the G-Westbrae shuttle in Berkeley. Today the car is preserved at the Western Railway Museum in Solano County, California. (Trimble collection.)

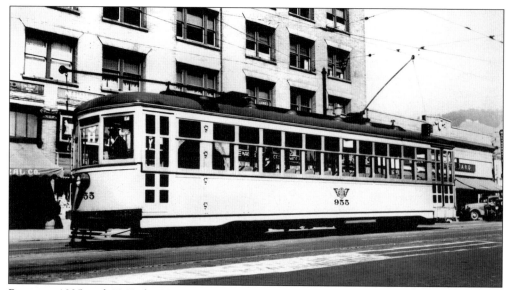

Between 1935 and 1942 the Key System's streetcars wore the white and yellow livery of East Bay Transit Company. The streetcar lines were numbered while the interurban lines were lettered. The No. 3 Line ran in Oakland from Broadway, Washington Street, San Pablo Avenue, and Grove Street to University Avenue in Berkeley; then connected with the B-Underhills, C-Piedmont, and E-Claremont interurbans. (Trimble collection.)

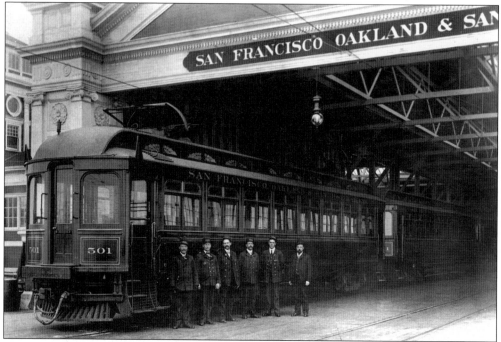

What was later to be called the Key Route and Key System opened for business as the San Francisco, Oakland & San Jose Railway on October 26, 1903. For convenience, the Key Route or Key System will refer to the company's network of interurbans, ferries, and local streetcar services. These handsome, orange interurban cars and crew pose for posterity at the Key Pier. (From the late Stephen D. Maguire, Trimble collection.)

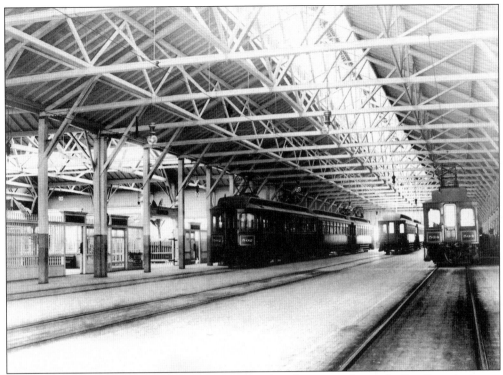

Inside the Key Pier terminal, passengers transferred to the orange ferries for San Francisco or to the Key's interurbans to continue their journeys to most East Bay cities. (Courtesy A/C Transit, Trimble collection.)

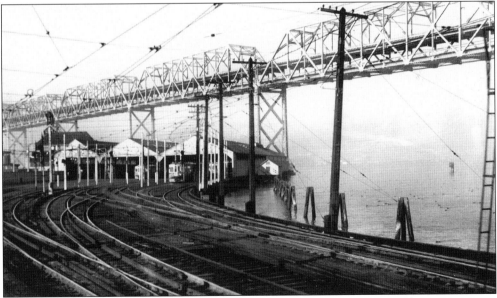

In May of 1933 a disastrous fire destroyed the terminal at the Key Pier. The structure was replaced by a steel building that, after the trains transferred to the Bay Bridge, was dismantled to rise again as an industrial building in Oakland. Here a pair of bridge units wait at the new terminal. (Wilbur C. Whittaker photo, Trimble collection.)

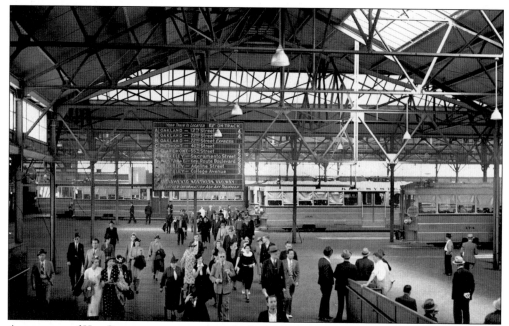

A company of Key System passengers disembarks from the orange and silver trains and walks to a waiting ferry. Note the sartorial finery that was *de rigueur* for going to San Francisco's downtown. (Wilbur C. Whittaker photo, Trimble collection.)

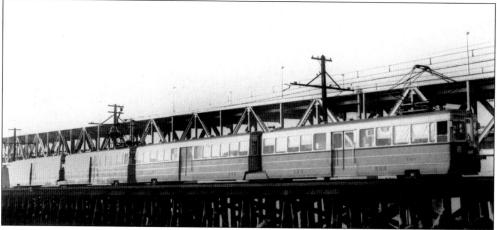

Headed by No. 148, a train of bridge units rolls on the Key Pier during its last days. The units were designed especially for the Key System. They were articulated (basically 2 cars sharing a center truck), 110 feet, 5½ inches long, weighed 69 tons, and seated 124 passengers. (Trimble collection.)

Alameda County's street railways began in 1863 with steam trains on Oakland's Seventh Street, connecting with a ferry to San Francisco's Davis Street pier. Steam train locals in the East Bay were acquired by the Central Pacific Railroad in 1869, and in 1911 the Southern Pacific began their electrification. In this view, Central Pacific Railroad No. 1272 is working a Berkeley local on Shattuck Avenue at Virginia Street. (Trimble collection.)

The Southern Pacific reacted to the Key Route's faster and cleaner electric trains by converting their noisy, dirty, and slower steam trains into a first-class electric system of their own. On November 7, 1911, the first electric on the Seventh Street line rolled with a great ceremony. (From the late Vernon J. Sappers, Trimble collection.)

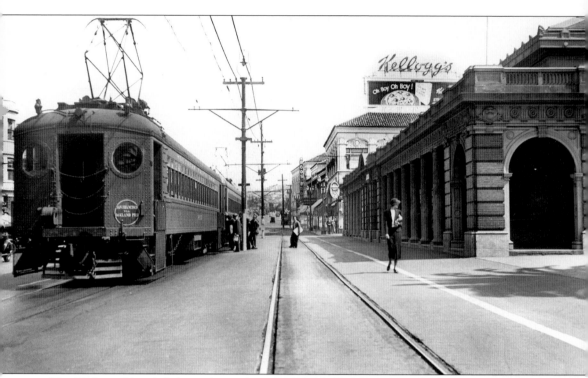

The 72-foot, 4½-inch behemoths used on the Espee's East Bay interurban services seated 116 people and were painted red, earning them the affectionate sobriquet "The Red Trains." This view is of Berryman Station in Berkeley. (Wilbur C. Whittaker photo, Trimble collection.)

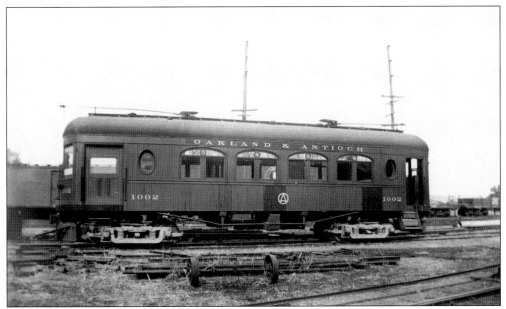

The Oakland & Antioch Railway was an interurban built in 1913 connecting Oakland and Sacramento and used the Key System's Fortieth Street tracks en route to the Key Pier where passengers rode the Key's ferries to San Francisco. On January 1, 1929 this road was merged with the former Northern Electric Railway to form the Sacramento Northern Railway, linking Oakland, Sacramento, and Chico. (Trimble collection.)

The Sacramento Northern's Oakland Terminal was at Fortieth Street and Shafter Avenue. These cars used either trolley poles or pantographs, and by throwing a switch they could run on either 600 or 1,200 volts DC. On Key tracks they used 600; on the bridge they used 1,200. (Trimble collection.)

The Southern Pacific ferry *Berkeley* is tied up at the Oakland Mole in a meet with the Southern Pacific Seventh Street Red Train. (Lorin Silleman photo, Trimble collection.)

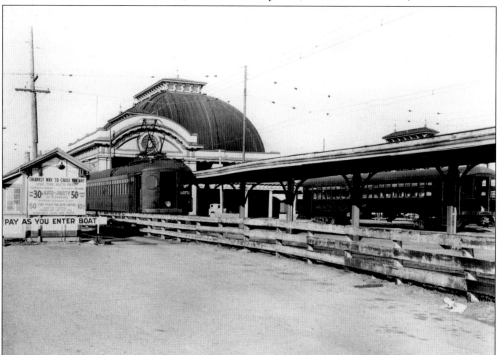

The ornate Alameda Pier was a relic of the South Pacific Coast Railway. In this 1930s view, the sign at the left advertises the Southern Pacific's automobile ferry as the "Cheapest way to cross the bay," in effect diverting business away from the company's own train-ferry services. (Southern Pacific photo, Trimble collection.)

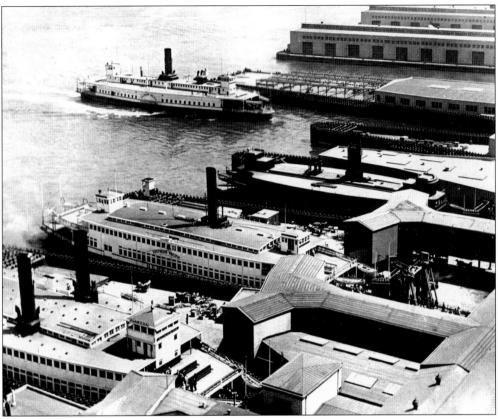

The intense ferry traffic from both commuter and transcontinental trains, fed by three street railways in San Francisco, made the Ferry Building the world's second busiest passenger terminal, topped only by London's Charing Cross Station. Pictured here, from top to bottom, the ferries are *Thoroughfare* (Southern Pacific), *Edward T. Jeffrey* (Western Pacific), *Berkeley* (South Pacific), and *Alameda* (Southern Pacific). (Bert Ward photo, Trimble collection.)

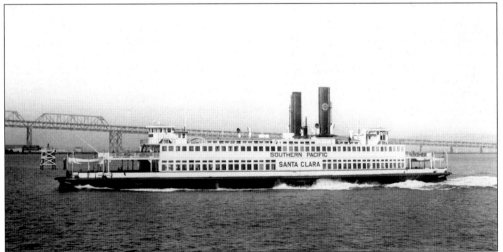

The *Santa Clara*, shown here, and the *Alameda* were sister ships and were the only twin stackers in the Southern Pacific's ferry fleet on San Francisco Bay. (Trimble collection.)

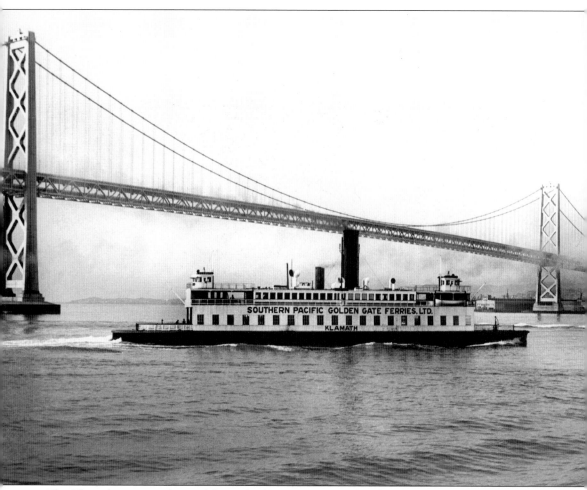

The *Klamath* was one of several ferries built to carry autos, thereby cutting into the interurban-passenger ferry trade. The new Bay Bridge in the background spells doom for all the ferries and the end of an era. Today the *Klamath* is a floating office building on San Francisco's waterfront. (Trimble collection.)

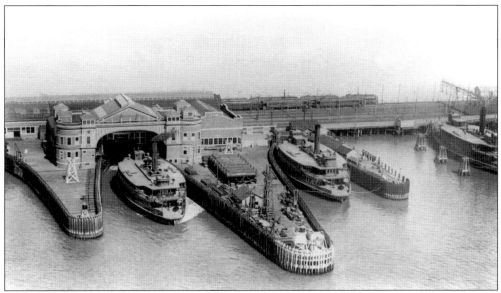

The Key Route's screw-driven ferries, shown here in the 1920s, were faster than the Southern Pacific's paddlewheelers. The Bay Bridge would render them all redundant. (Trimble collection.)

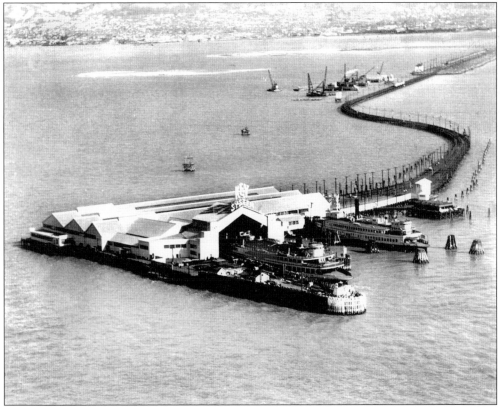

A brace of Key System boats is tied up at the Key Pier while the first steps of construction of the Bay Bridge are taking place. The landfill used for the Key's tracks is now part of the bridge's toll plaza. (Courtesy A/C Transit, Trimble collection.)

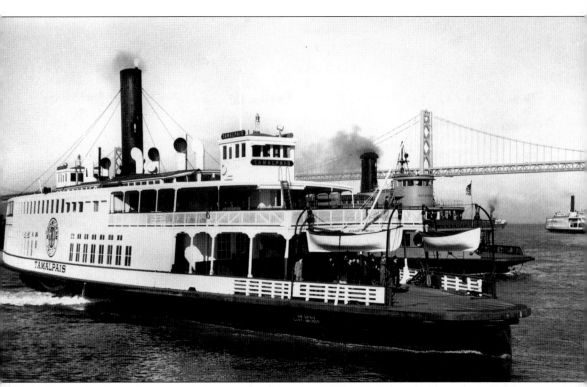

The artful eye and camera of photographer/historian Wilbur C. Whittaker have captured for us the final days of Bay Area ferries as the Northwestern Pacific Railroad's *Tamalpais*, from Sausalito, and the Key System's *Yerba Buena II*, from Oakland, race to the Ferry Building while the Espee's *Berkeley* heads for Oakland. (Wilbur C. Whittaker photo, Trimble collection.)

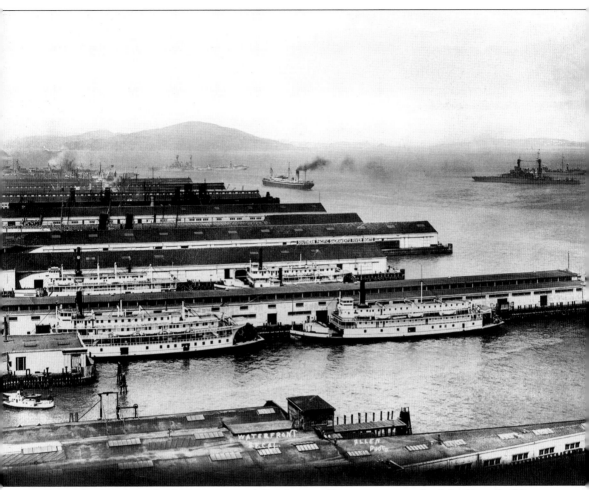

Sternwheelers from the Sacramento and San Joaquin Rivers tie up north of the Ferry Building while a pair of U.S. Navy ships head for sea. This photo was taken during the 1920s when riverboating in California was in its final glory. Later, trucks would roll over the state's highways and bridges, starving the riverboat business and forever changing Northern California's transportation patterns. (Trimble collection.)

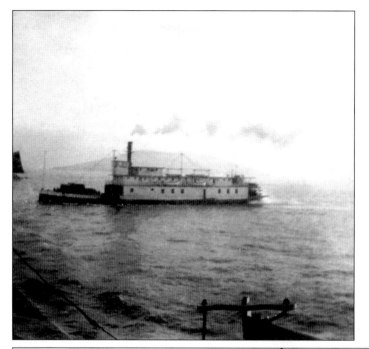

The sternwheeler *Gold*, owned by the Petaluma & Santa Rosa Railroad, churns her way northward from San Francisco to San Pablo Bay, and thence up the Petaluma Creek to Petaluma, a voyage of about six hours, depending upon the tides. (Trimble collection.)

Bay scows such as the *Alma* constituted a floating system of highways as their flat bottoms allowed them to sail up the narrow and shallow sloughs that feed into the bay and carry cargoes large enough to do justice to today's trucks. However, they were slow and might take three days to do what a semi can do in a couple of hours, thanks to the bridges and highway connections. (San Francisco Maritime National Historical Park, Trimble collection.)

Two

THE PROSPECTUS

When San Francisco's Emperor Norton "commanded" a bay span in 1872, neither the technology nor the necessary financing was available. Yet the idea persisted. From 1914, the first year in which California's motor vehicle registrations were recorded by counties, until 1930, registrations for both Alameda County and San Francisco rose from 20,530 to 301,584. Meanwhile, their populations rose from 663,043 in 1910 to 1,109,277 in 1930, meaning there was a sufficient market for toll charges to eventually retire the financing bonds. It was time for serious proposals.

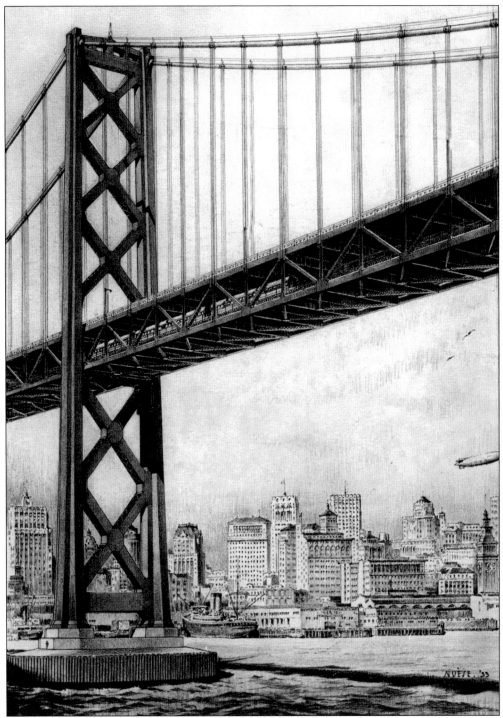

Planning began with the Hoover-Young Bridge Commission (named for President Herbert Hoover and California's Governor C.C. Young) in October of 1929. Proposals included these artist's sketches. (Toll Bridge Authority, Alioto collection.)

Among San Francisco's many off-beat characters, none has been more endearing than Norton I, the self-proclaimed emperor of the United States and protector of Mexico. On March 23, 1872, he ordered the San Francisco newspaper *Pacific Appeal* to publish the following:

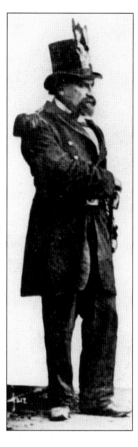

PROCLAMATION

The following is decreed and ordered to be carried into execution as soon as convenient:

I. That a suspension bridge be built from Oakland Point to Goat [now Yerba Buena] Island, and thence to Telegraph Hill; provided such bridge can be built without injury to the navigable waters of the Bay of San Francisco.

II. That the Central Pacific Railroad Company be granted franchises to lay down tracks and run cars from Telegraph Hill and along the city front to Mission Bay.

III. That all deeds of land by the Washington Government since the establishment of our Empire are hereby declared null and void unless our Imperial signature is first obtained thereto.
—NORTON I

(Trimble collection.)

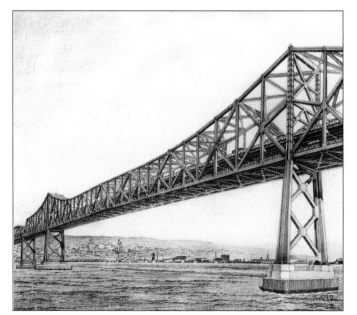

In this drawing the artist shows the cantilever section of the Bay Bridge, facing east toward Oakland and the city of Alameda. The details and their accuracy are remarkable, comparing favorably with photography of the same scene. (Toll Bridge Authority, Alioto collection.)

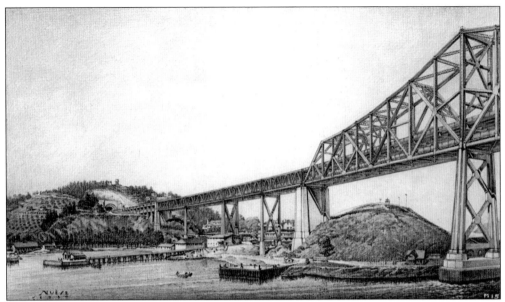

This artist's conception has us looking west to Yerba Buena Island as the cantilever section leads to what will be the world's tallest as well as widest tunnel. (Toll Bridge Authority, Alioto collection.)

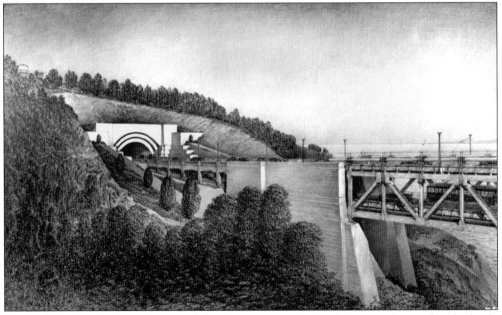

The Toll Bridge Authority's proposal drawings are amazing in their attention to detail, clearly reflecting the future finished product. This view is facing east toward the west portal of the Yerba Buena Island Tunnel. (Toll Bridge Authority, Alioto collection.)

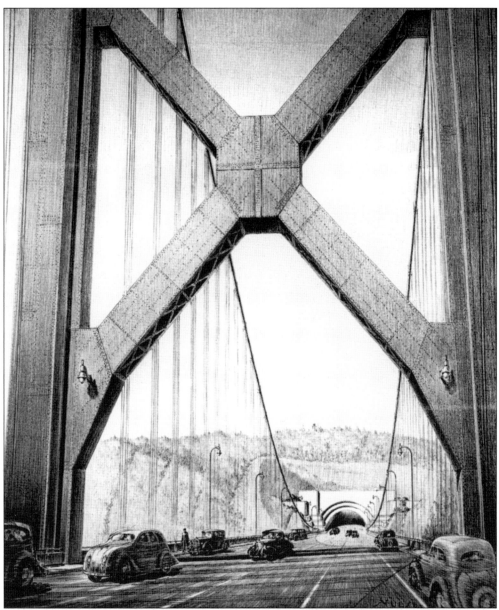

As planned, the upper deck would have three lanes for eastbound and three lanes for westbound traffic. This drawing was executed in 1934, long before the day when California would register 25 million motor vehicles a year. (Toll Bridge Authority, Alioto collection.)

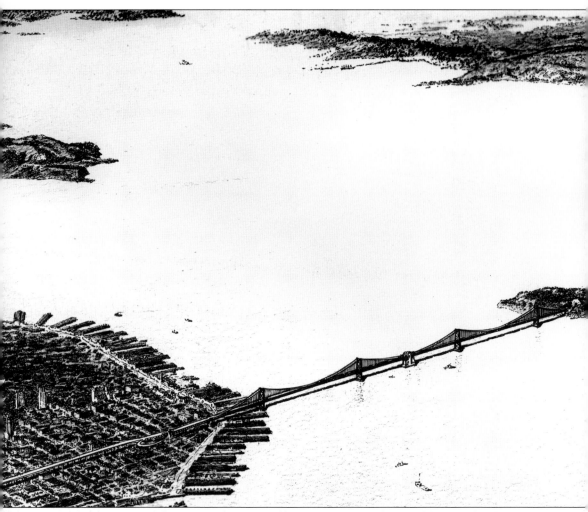

Among the proposal drawings is this view of how the entire bridge would look. The drawing is in such detail that a keen eye can spot many landmarks, such as Angel Island, Tiburon Point,

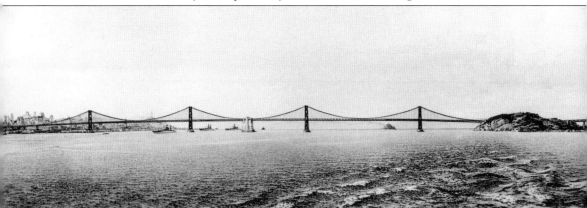

In this drawing we are invited to view the future San Francisco–Oakland Bay Bridge from sea level. From end to end of the approaches, this drawing represents 43,000 feet—over 8 miles.

San Quentin, and Richmond. (Toll Bridge Authority, Alioto collection.)

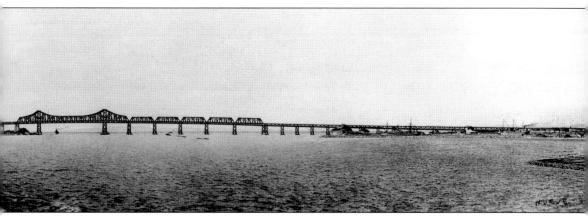

What a concept! (Toll Bridge Authority, Alioto collection.)

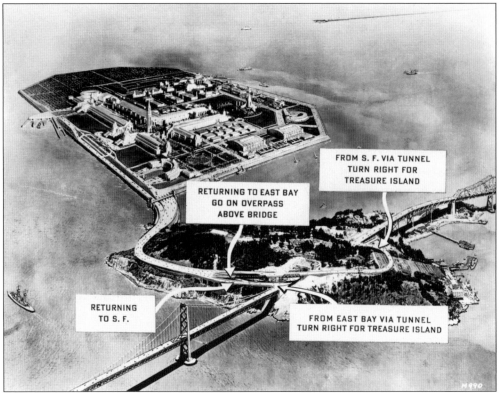

FROM S. F. VIA TUNNEL
TURN RIGHT FOR
TREASURE ISLAND

RETURNING TO EAST BAY
GO ON OVERPASS
ABOVE BRIDGE

RETURNING
TO S. F.

FROM EAST BAY VIA TUNNEL
TURN RIGHT FOR TREASURE ISLAND

This aerial drawing shows two segments of the bridge converging on Yerba Buena Island, the road approaching the future Treasure Island, and the Golden Gate International Exposition. This view was executed in 1937, working from photographs. (Toll Bridge Authority, Alioto collection.)

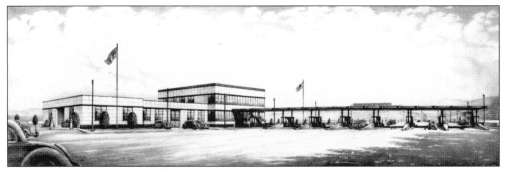

Executed in 1936, this drawing of the proposed toll plaza is indicative of an earlier generation's thinking that 14 lanes for toll collections, with motorists paying each way, would be adequate. Obviously, even the best available planners were bereft of a crystal ball. (Toll Bridge Authority, Alioto collection.)

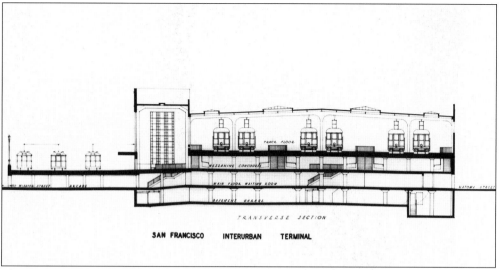

SAN FRANCISCO INTERURBAN TERMINAL

The Bay Bridge would feature a double-track railway on the lower deck, bringing commuters in and out of a six-track terminal in San Francisco. Upon arrival, three tracks of streetcars would bring transbay travelers to their ultimate destinations. (Toll Bridge Authority, Alioto collection.)

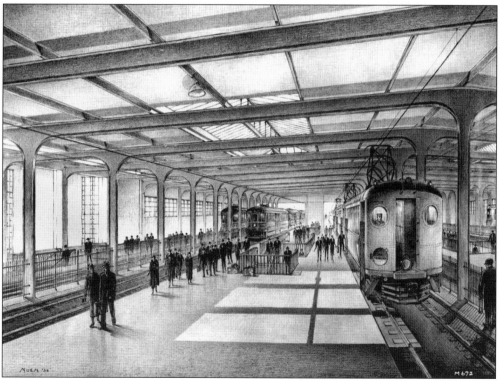

Art deco and futuristic, yet making the best use of existing rail technology, the interior of the Transbay terminal had open ends, skylighting, and plenty of windows for natural light, supplemented by an excellent electric lighting system. Dark corners and deep shadows were conspicuously avoided. (Toll Bridge Authority, Alioto collection.)

33

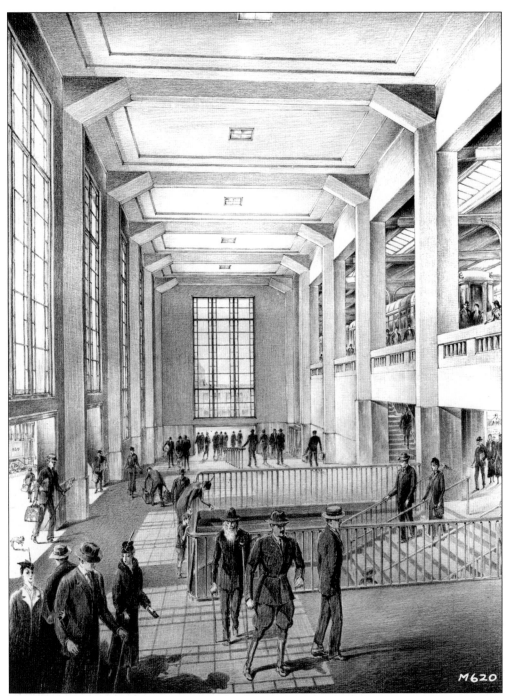

Long before the Americans with Disabilities Act, the proposed Transbay Terminal nevertheless offered large ramps in addition to steps for ingress and egress. In later years this facility would serve buses equally well; the only modifications necessary were to alter the track beds. (Toll Bridge Authority, Alioto collection.)

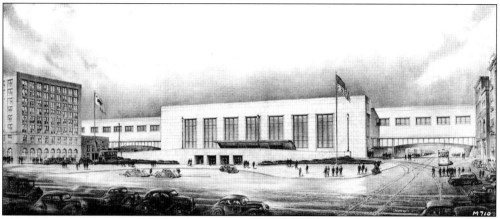

This drawing shows the Mission Street side of the proposed Transbay Terminal. A pair of streetcar tracks on First Street (right) brought both Market Street Railway and the Municipal Railway streetcars up the ramp in front and then back to Market Street along Fremont Street (left). The concourse at street level allowed access for taxis, automobile drop-offs, and eventually buses. Pedestrians entered and exited from three sides at street level as well as from the streetcar ramps. (Toll Bridge Authority, Alioto collection.)

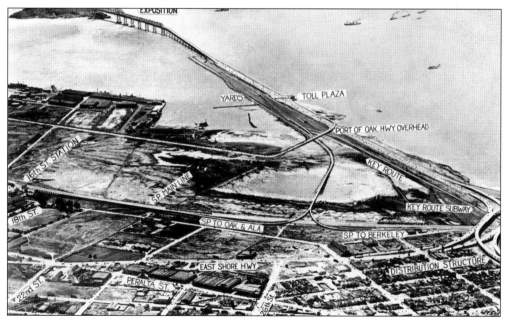

Again the artist has superimposed a concept drawing upon a photograph, this time with labels—a perhaps unwitting gift to future historians since the plans followed true to form. (Toll Bridge Authority, Alioto collection.)

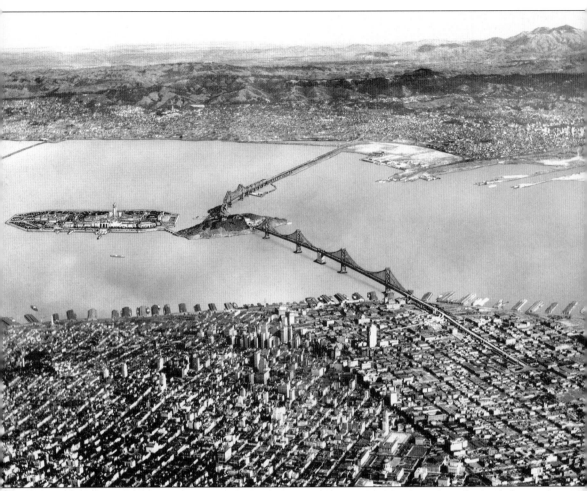

This aerial photograph records the skylines of San Francisco, Oakland, Emeryville, Berkeley, and Albany. Also shown are the ferry piers for the Key System, the Southern Pacific Oakland Mole, Western Pacific Railroad, and the city of Alameda. The artist has superimposed the proposal drawings for Treasure Island and the bridge. (Toll Bridge Authority, Alioto collection.)

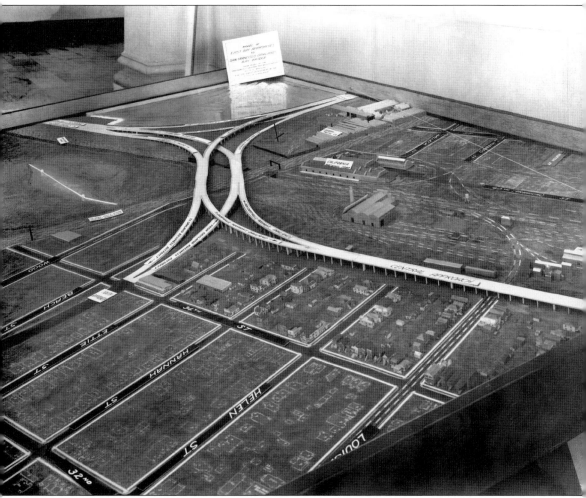

Now was the time to get off the drawing board and do mockups of the bridge and approach ramps. These models were displayed in the Ferry Building in San Francisco and helped to gain public approval for the project. (Haas-Schreiner photo, Toll Bridge Authority, Alioto collection.)

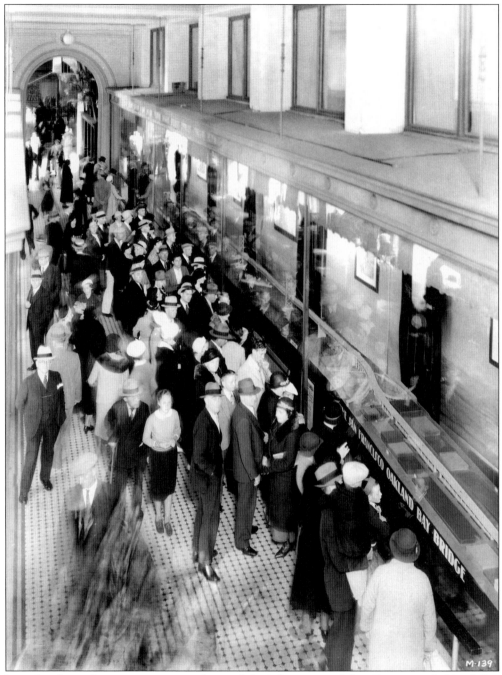

It took a long glass case to protect this model of the proposed San Francisco–Oakland Bay Bridge, shown here on display in the Ferry Building. This 1934 photograph shows there was a popular interest in the model, which represented faster and more efficient public transit as well as potential jobs at good union wages during the Great Depression. (Toll Bridge Authority, Alioto collection.)

Three

THE FOUNDATIONS
FOR THE BRIDGE

The San Francisco side of the bay is deep water, while the east side consists of shoals and mudflats. In between lies Yerba Buena Island. East of the island a cantilever bridge would do, but west of the island a towering suspension bridge was needed so that U.S. Navy ships as well as merchantmen could sail as freely as the watery depths allowed. During the Great Depression this meant plenty of hard—and dangerous—work for the skilled men who forged the this extraordinary bridge.

In the era of sailing ships, vessels of every description tied up at San Francisco because it was deep water. The Oakland side, however, is shoal water, accounting in part for the 3.2-mile-long Key Pier, and today requires constant dredging for modern container ships. Deep water mandated the tall suspension bridge section, while a cantilever was sufficient for the eastern side. (San Francisco Maritime National Historical Park, Trimble collection.)

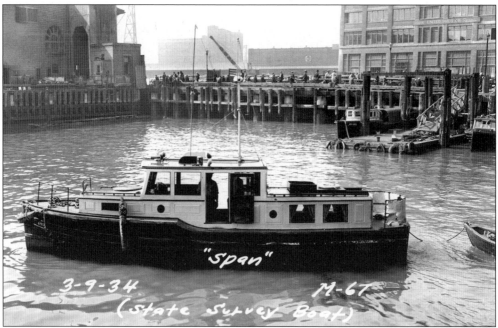

Ironically, for a bridge that would send so many vessels into retirement, the Bay Bridge builders began with a small navy of their own. This is the survey boat *Span*. (Alioto collection.)

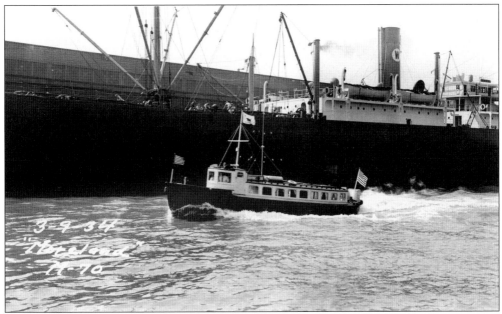

The bridge engineer's boat was the *Moreland*, shown here cutting her way past a docked freighter. (Alioto collection.)

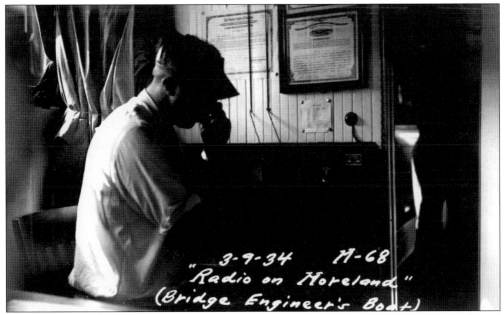

Aboard the *Moreland* the radioman stays in touch with others of the team. On the bulkhead above the radio are the vessel's papers. Such things as cellphones and hand-held radios had yet to be invented. (Alioto collection.)

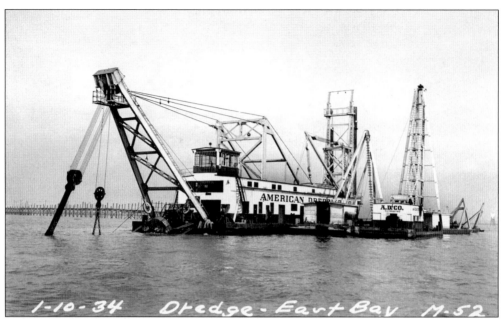

1-10-34 Dredge-East Bay M-52

In action at left on January 10, 1934, is a dredge of the American Dredging Company. At her portside is a pile driver from the same company. (Alioto collection.)

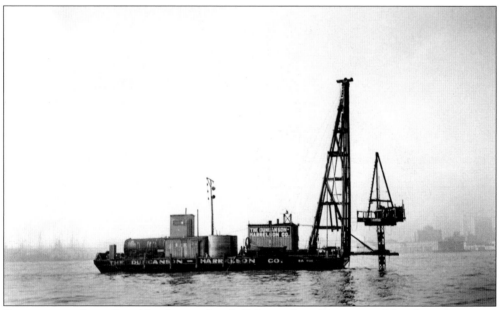

Beginning work on Pier No. 2 was this drill barge from Duncanson-Harrelson Company, drilling more than 200 feet below the sometimes choppy and always cold waters of the bay. (Alioto collection.)

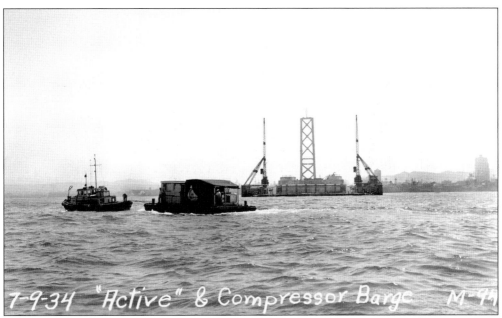

7-9-34 "Active" & Compressor Barge M-94

Here we see the *Active* towing a barge carrying a compressor across the bay while at center a tower rises out of the water. In the right background are Twin Peaks, indicating that this view is facing west. (Alioto collection.)

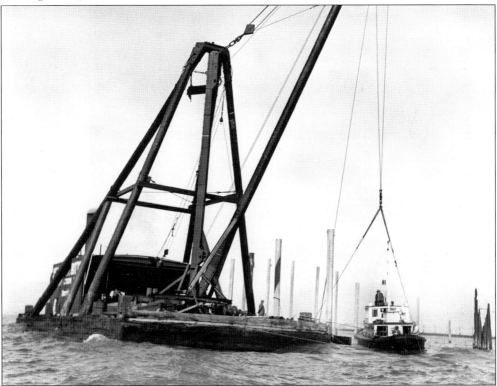

Pilings have been sunk but the real story is how the photographer has recorded the force of the tides on the bay. How do you get a flat-bottomed barge to hold still? (Alioto collection.)

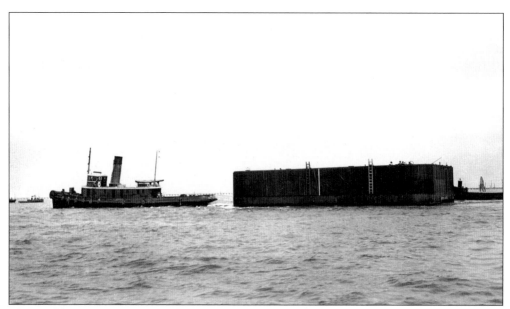

The workhorses of any harbor are the tugboats that muscle ocean-going ships in and out of often very tight berths. Equally impressive was their contribution to the building of the Bay Bridge. In this photo a pair of these nautical quarterhorses tow and shove a caisson into place. (Alioto collection.)

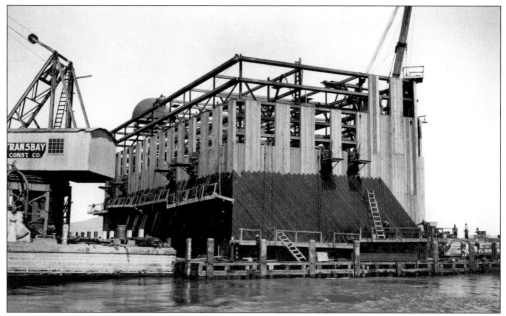

Workmen in this photo are placing the diagonal sheathing and the cylinders on Caisson No. 5. To gain some perspective of the size of this box in which men will work, compare the height of the caisson to the heights of the workmen. This project was big in every aspect. (Courtesy of Standard Oil Company, Alioto collection.)

With the prodigious quantities of steel and concrete used in the bridge's construction, the use of lumber in the cofferdam for Pier No. 57 would appear to be a bit incongruous, yet there it is. (Alioto collection.)

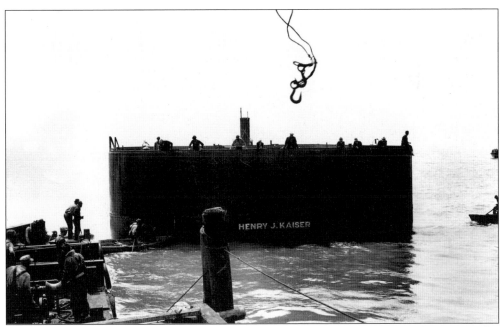

The hardy and skilled workmen who built the bridge were gifted with nerves of the same steel it took to build the bridge itself, as this photo attests. Men are standing in skiffs while another worker nonchalantly sits atop the structure with legs dangling over the side. (Alioto collection.)

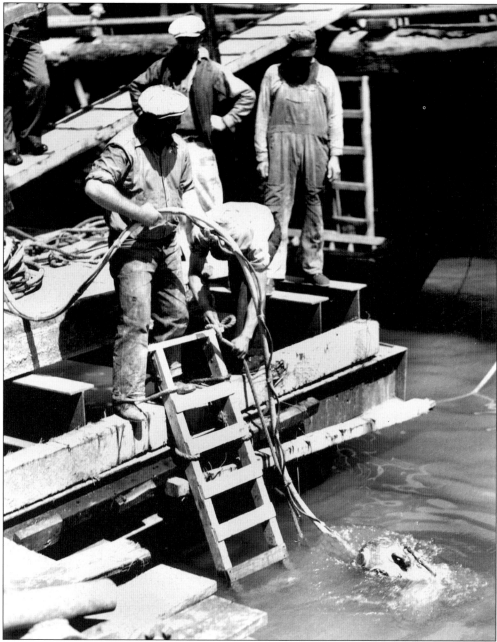

Chief diver Bill Reed descends into the bay to perform another job. Working in depths with water pressure at 100 pounds per square inch, he could only stay under for 10 to 15 minutes at a time and then surface to be rushed to a decompression chamber. Where Reed worked there was no light, so he literally had to feel his way around. On one dive he had to set an underwater dynamite charge. He was paid $15,000 per year plus $1 for every foot for every dive—money well earned! (Haas-Schreiner photo, Alioto collection.)

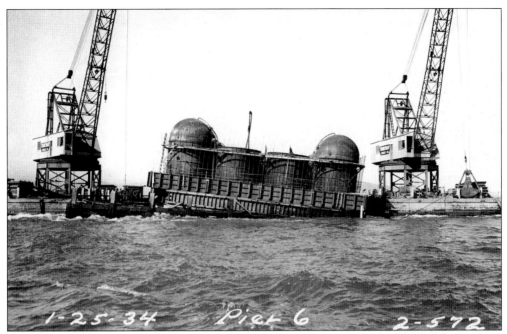

It's January 25, 1934, the bay's tides are churning, and the caisson for Pier 6 won't settle properly because it's hung up on an underwater boulder. Diver Bill Reed had to go down and set a dynamite charge to blow up the boulder, after which the caisson slowly settled into proper position. (Alioto collection.)

This will be the book's "mystery photo." The large structure in Oakland's outer harbor appears to be a caisson for the Bay Bridge, which would date the photo no earlier than 1933. Yet in the right background is the Southern Pacific ferry *Encinal*, and in back of her appears to be the *Garden City*, which was retired in June of 1929. However, published sources list the *Encinal* as having been dismantled in December of 1930. The only other indicator is that the Key Pier is in operation with no bridge units in sight. (Alioto collection.)

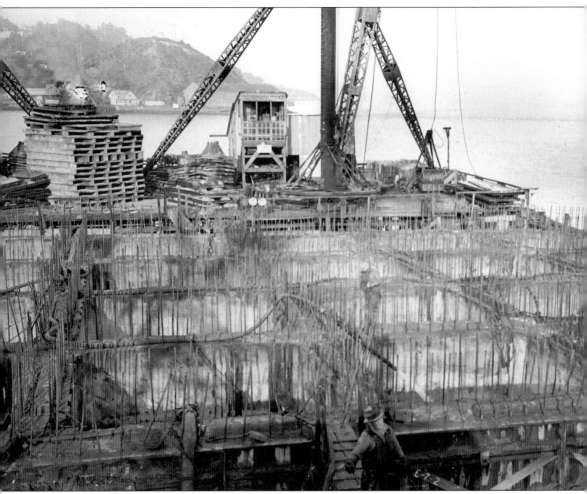

And now to fill this thing with concrete—and plenty of it. One pier was sunk 242 feet below water, was bigger than the largest of the Pyramids, and required more concrete than New York's Empire State Building. In fact, the 1,000,000 cubic yards of concrete and 152,000 tons of steel used in building the bridge could construct 35 San Francisco Russ Buildings (36 stories tall), plus another 35 Los Angeles City Halls. (Alioto collection.)

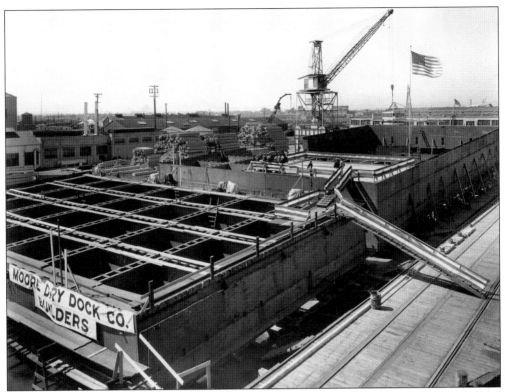

Moore Dry Dock Co. built bay ferries and other vessels and did all types of repairs and rebuildings. Here the company is erecting sections of the towers for the Bay Bridge. This photo was made by San Francisco's Gabriel Moulin Studios, which took many high-quality photos for the Toll Bridge Authority, bequeathing to us a marvelous visual record of bridge construction before the days of universal color photography and camcorders. (Moulin Studios photo, Toll Bridge Authority, Alioto collection.)

How many millions of motorists have driven on the Bay Bridge without knowing what those giant towers on the bridge were like on the inside? A section of Tower 2 is on its side before being transported out on the bay, and the view is definitely riveting. (Alioto collection.)

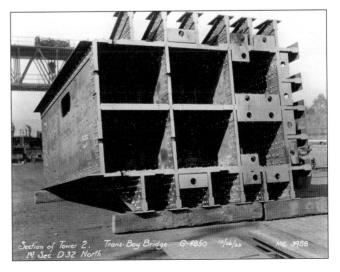

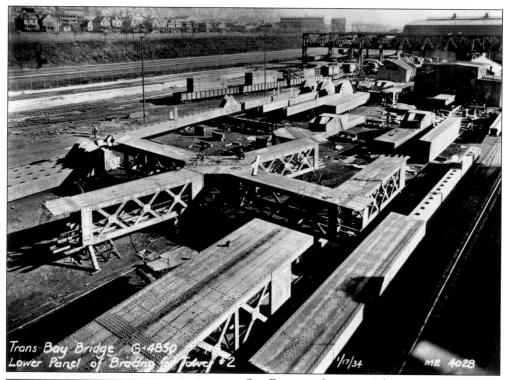

Trans·Bay Bridge G-4850
Lower Panel of Bracing for Tower #2 1/17/34 ME 4028

San Francisco historian John B. McGloin, S.J. called the Bay Bridge "a symphony in steel." An apt description as each part had to be fashioned and riveted with the precision one would expect when Herbert von Karajan was conducting Mozart. (Alioto collection.)

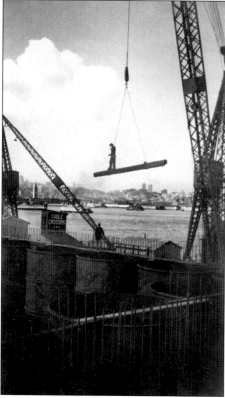

A steelworker shows nerves of steel on a girder of steel, almost in defiance not only of the Southern Pacific-Golden Gate Ferries, Ltd. auto ferry *New Orleans*, but also of the laws of gravity. (Courtesy of Standard Oil Company of California, Alioto collection.)

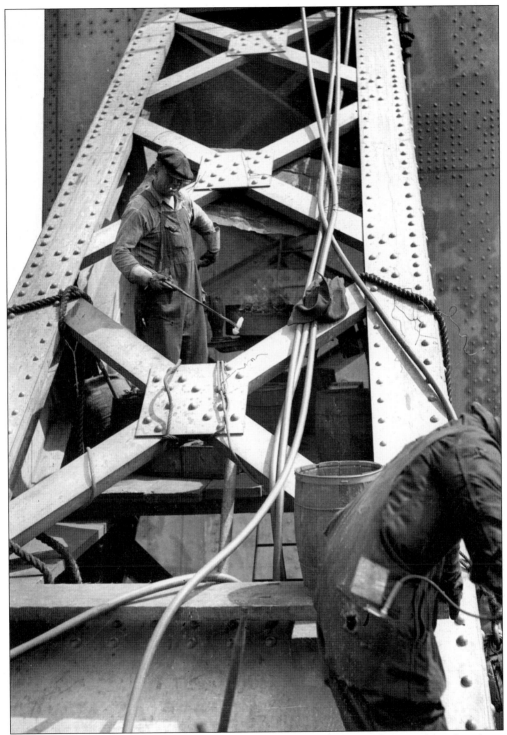

With a face blackened from soot and grime, a cigarette dangling from his mouth, and a white-hot rivet ready for placement, Walter G. Swanston prepares to add another permanent dimension to what will be the mightiest bridge in the world. (Alioto collection.)

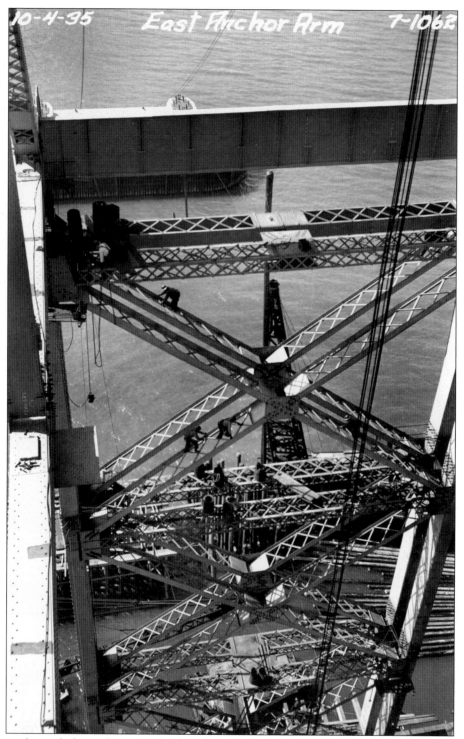

The authors ask the reader not to think of these bridge builders as daredevils, but rather as highly skilled men who were glad to get work during the Great Depression. By taking these jobs, the men put far more into the economy of the Bay Area than they ever received from it. (Alioto collection.)

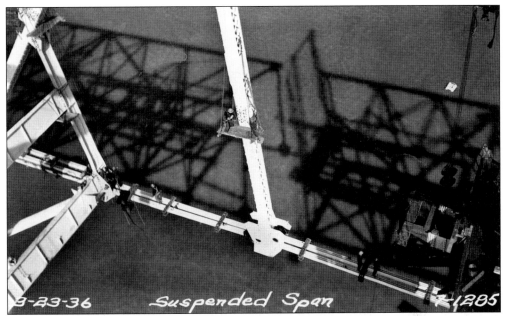

High above the bay, without a safety net, a riveter pounds a hot rivet with the full swing of a sledge hammer while below another bridge builder walks unaided, apparently so focused on what he's doing that he doesn't stop to think of either the cold water below or the possibility of sharks. Although 12 men lost their lives building the bridge, this was well below the rule of thumb of one life for each million dollars of bridge construction. (Alioto collection.)

Looking to the west, a pair of towers rise high above the bay waters as if trying to go nose to nose with the soaring seabirds. Today, peregrine falcons are known to nest amidst the steel girders of the Bay Bridge. (Courtesy of Standard Oil Company of California, Alioto collection.)

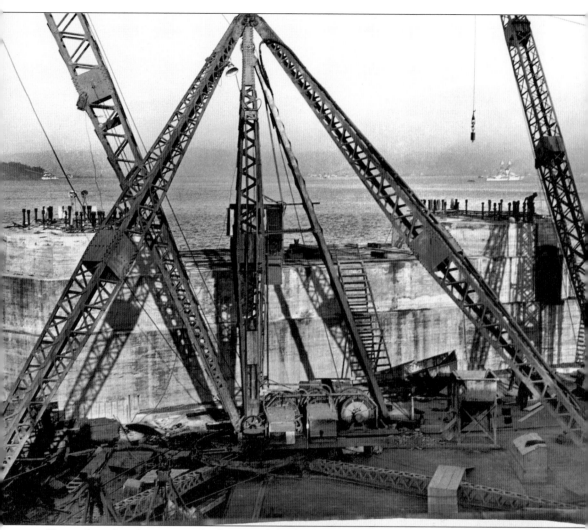

Tons of steel and concrete, the brawn of the bridgebuilders, the brains of the planners and engineers, and confidence in American know-how have combined to create Pier 2 for this indomitable bridge. (Toll Bridge Authority, Alioto collection.)

Four

BUILDING HIGH
ABOVE THE WATER

There were five basic phases in constructing the San Francisco–Oakland Bay Bridge: the cantilever section, the tunnel through Yerba Buena Island, the suspension section, the approach and exit ramps, and the Transbay Terminal. At a total cost of $80.8 million this would be the costliest civil engineering project in history, the world's longest bridge, and would have the world's biggest tunnel. This colossal structure would forever alter the Bay Area's transportation patterns.

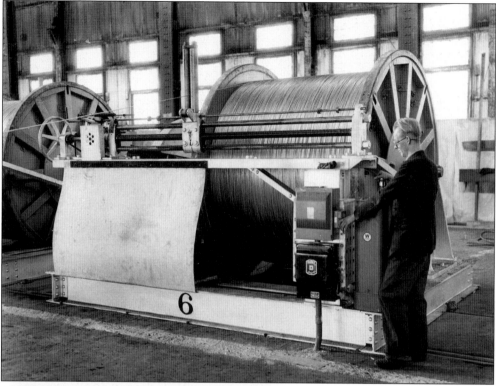

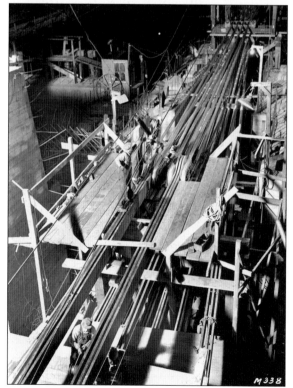

The 2 cables that support the suspension portion of the bridge are each 28¾ inches in diameter, and each contain 17,664 wires. To assemble 70,000 miles of pencil-thick steel wire into a pair of cables was an exacting task. (Toll Bridge Authority, Alioto collection.)

Converting 17,664 steel wires into a single cable required a cable-making plant, and in this photo we see the smaller strands being brought together to create a steel rope. There could be no slack or stretching, so constant tension had to be maintained during the process. (Toll Bridge Authority, Alioto collection.)

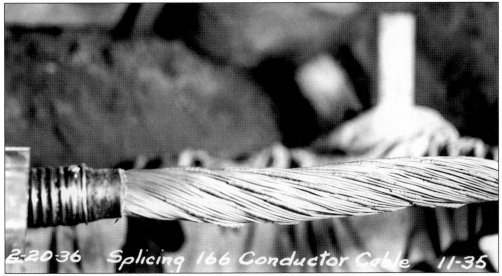

With literally miles of steel rope involved, splicing was necessary at times, which was a skill in itself. Splicing, rather than simple coupling, was necessary so that at no point would there be a lack of strength or change in size. (Alioto collection.)

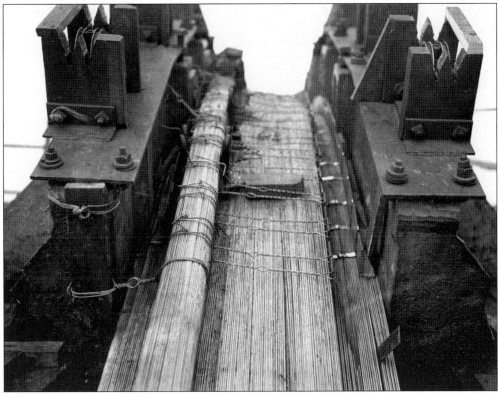

The next stage of cable assembly was to combine the rope to create cables, to be joined again into even larger cables, keeping every strand in its proper position. Steel ropes, triple-wrapped, were needed to hold everything in place. When completed, the bridge would be capable of carrying a load of 7,000 pounds per foot. (Alioto collection.)

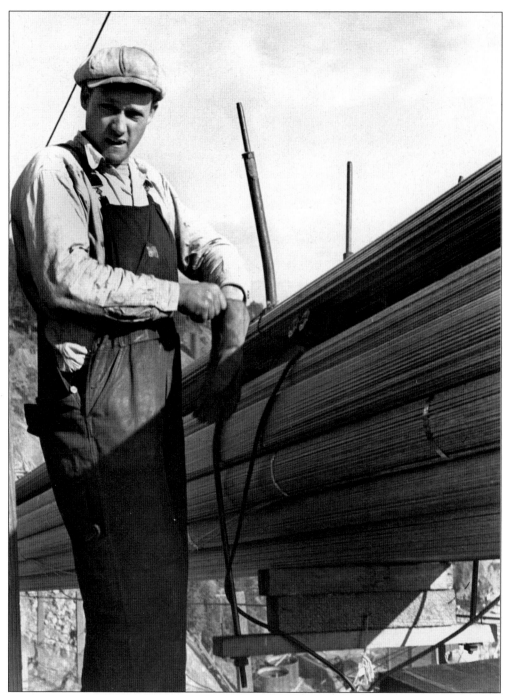

Jack Morris, pictured here at 27 years old, worked the bridge from the start. This San Franciscan had previously worked on the St. Louis Bridge and now was working on the Bay Bridge as an adjuster, receiving wages of $1.37½ per hour. The job wasn't easy; on August 14, 1935, his arm was broken in two places. Jack was married and had two children, a boy and a girl. When asked if he wanted his son to do the same type of work, he replied "Anything but a bridge man." (Toll Bridge Authority, Alioto collection.)

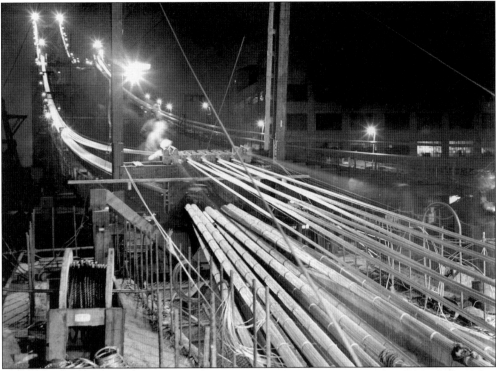

This classic night photo shows the huge suspension cables being assembled and then being fed to the towers. Although this was a time exposure, one workman was more intent on his job than being recorded for posterity, so he appears as a ghost. (Toll Bridge Authority, Alioto collection.)

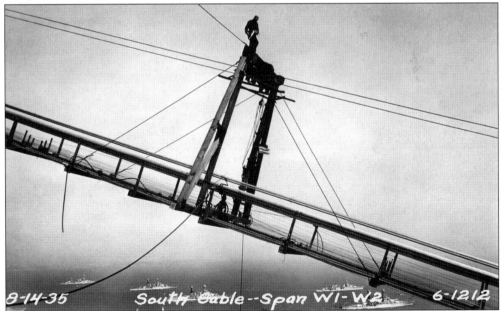

8-14-35 South Cable--Span W1-W2 6-1212

The Navy flotilla on San Francisco Bay is an indicator of the heights at which our subject is working, and without a safety net. This is cause enough to admire the courage of those who built the mightiest bridge in the world. (Toll Bridge Authority, Alioto collection.)

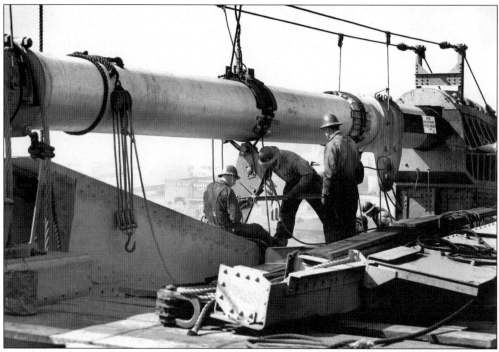

As the wire cable is fed through the pier at the upper right, it then becomes encased in a steel sheath. A sharp eye will note an American flag where the men are working. The posted sign reads "NOTICE DO NOT USE THIS PIER FOR TOILET PURPOSES." (Alioto collection.)

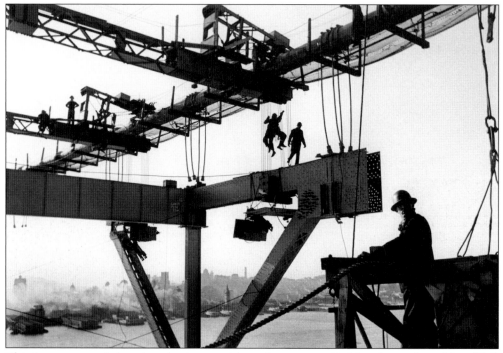

This is not a posed shot, but the juxtaposition of two men climbing down the cables. (Toll Bridge Authority, Alioto collection.)

60

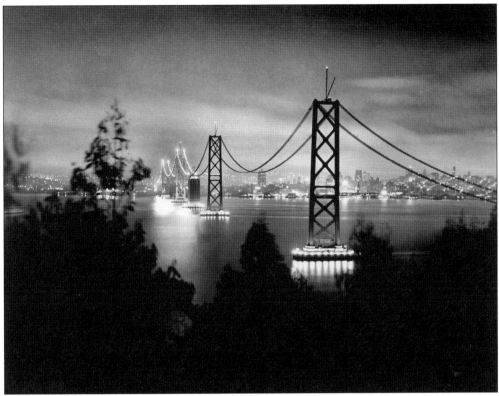

Looking toward San Francisco from Yerba Buena Island we see a city aglow with light and an incomplete Bay Bridge. The lights on the piers and the two western spans are on, probably for safety. The Ferry Building with its famed clockface is visible to the right of the closest tower. (Alioto collection.)

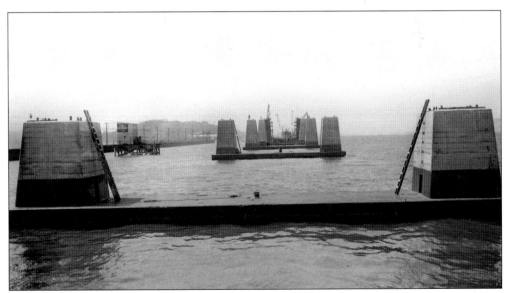

No, this is not a sea monster in San Francisco Bay but rather the series of piers used to support the cantilever section of the Bay Bridge. (Alioto collection.)

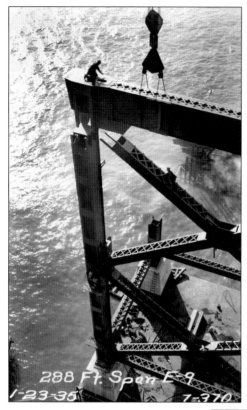

288 Ft. Span E-9
1-23-35 7-370

The cantilever section was much easier to construct than the suspension section. Yet as we see a beam assembly being lowered by crane into place, we're reminded of the absolute precision so necessary in every phase of building the Bay Bridge. (Alioto collection.)

Readers of a certain age will recall the popular Erector Sets by A.C. Gilbert when viewing the many bracings needed to support a double-deck bridge capable of holding two motorways and a railway. Yet the bridge still had to be resistant to earthquakes, tides, salt air, heavy winds, and expansion and contraction of the steel during weather changes. (Toll Bridge Authority, Alioto collection.)

Near Yerba Buena Island parts of the cantilever section are being readied for riveting together for a web of steel to connect Oakland with Yerba Buena Island. Ultimately, 22 million rivets went into the bridge. (Toll Bridge Authority, Alioto collection.)

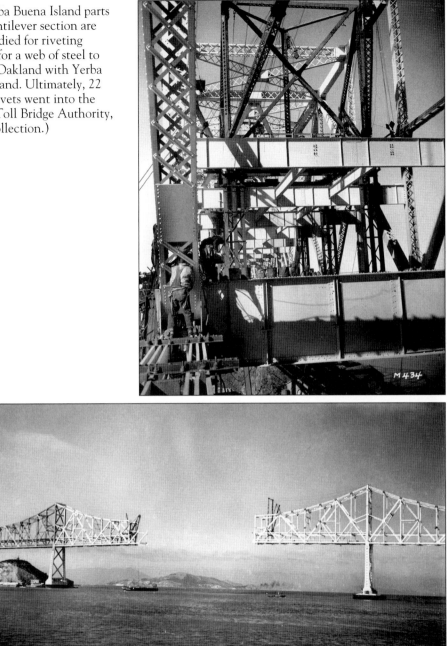

3-5-36 Suspended Span 7-1197

The last cantilever section was towed out by barge, then lifted into place by a floating crane. Although calculated to the last fraction of an inch, the south side was found to be four inches too big while the other side fit, due to the warm sun that caused the steel to expand while the north side was cooled by a cold wind in from the Golden Gate. The crews had to wait several hours while the weather allowed the 96-foot, 21,000-ton section to contract. Then it was then placed with the rivet holes matching exactly. (Alioto collection.)

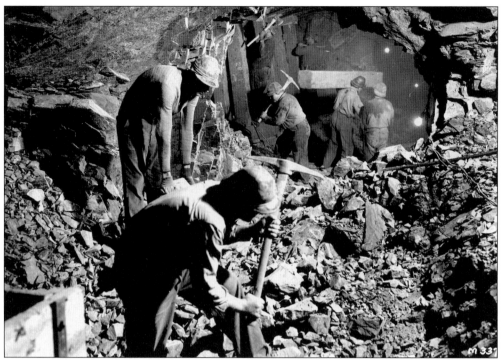

In spite of all of the heavy machinery used in building the Bay Bridge, much of the work came down to old-fashioned pick and shovel. Here the men are beginning to bore the tunnel through Yerba Buena Island, where strong backs were necessary. (Toll Bridge Authority, Alioto collection.)

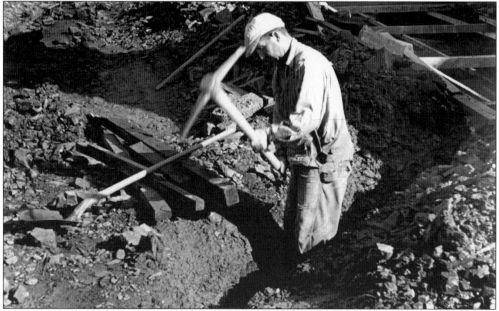

J.O. Wloyd, a 39-year-old laborer from Oakland and father of two, was hard at work when this photo was taken, doing his part to help bore the Yerba Buena Island Tunnel. When asked if he wanted his son to do the same type of work, he said he'd rather have him be a doctor or an engineer. (Toll Bridge Authority, Alioto collection.)

To make the bore for the Yerba Buena Island
Tunnel, an air compressor and drill were
required. Because of the height of the bore, the
equipment was placed on a platform that was
then suspended from above by cables and
pulleys. (Courtesy of Standard Oil Company of
California, Alioto collection.)

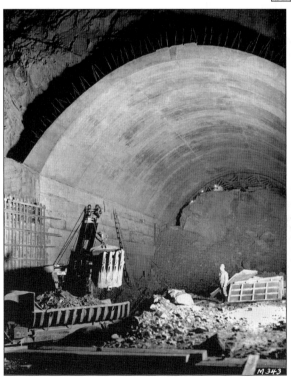

The tunnel had to be wide enough to
accommodate six lanes of
automobiles and tall enough to hold
two roadways. The fellow in boots
and helmet is probably a supervising
engineer, judging from his attire.
(Toll Bridge Authority,
Alioto collection.)

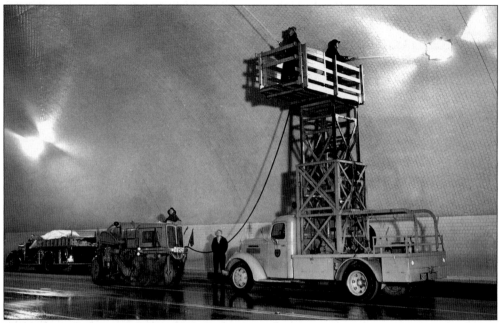

At 58 feet wide, this was the world's largest tunnel both in diameter and in height. In fact, without the upper-deck roadway, a four-story house could be towed through it. Because of the second level, few ever comprehend the engineering marvel of the tunnel. (Toll Bridge Authority, Alioto collection.)

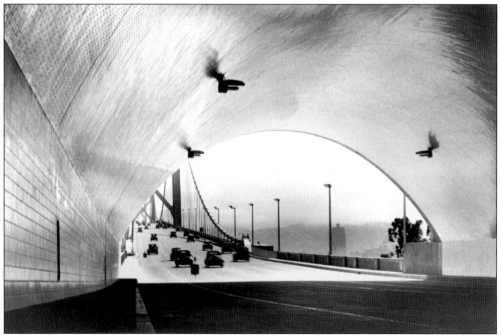

This is the upper deck of the Yerba Buena Island Tunnel as it appeared from opening day of the bridge until 1958 when it was reconfigured for one-way vehicular traffic on each deck. The upper-deck roadway obscures the tunnel's actual height, and note that there is no safety barrier in the center. (Alioto collection.)

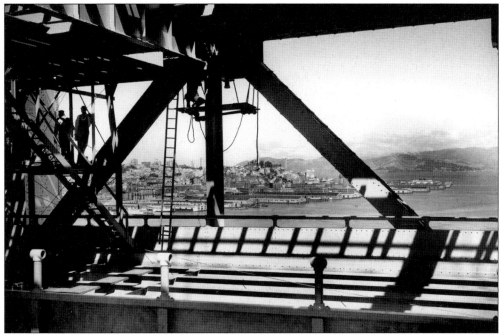

A final look from the suspension segment of the bridge toward San Francisco shows the venerable ferryboat *Eureka* pulling out from her slip at the Ferry Building on yet another trip to Sausalito, the auto ferry *Napa Valley* in from Vallejo, and in the center distance the Golden Gate Bridge, also under construction. (Toll Bridge Authority, Alioto collection.)

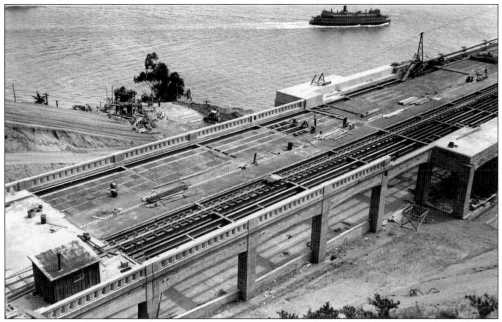

A passing Key System ferry knows its days are numbered as plating on the suspension portion of the bridge is applied near the west side of Yerba Buena Island. Ferryboat commuters watched the progress intently and often made friendly bets on how much work would be accomplished within a certain amount of time. (Toll Bridge Authority, Alioto collection.)

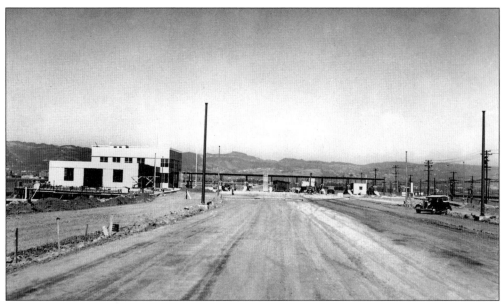

In 1929 the California legislature appropriated $50,000 for planning the bridge, followed by another appropriation of $650,000 for further design and survey work. In December of 1932 the Reconstruction Finance Corporation—with a push from President Hoover, himself an engineer and Californian with faith in the project—agreed to purchase $61.4 million in bonds from the Toll Bridge Authority to be repaid from bridge tolls. This is the toll plaza under construction. (Toll Bridge Authority, Alioto collection.)

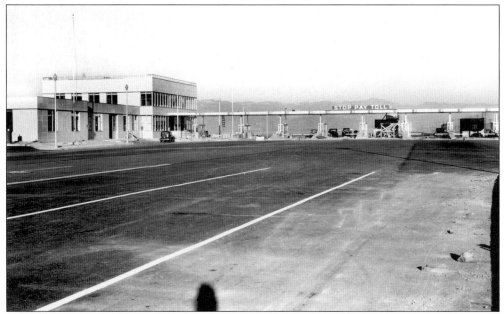

The nearly completed toll plaza is almost ready for business, although not all of the road stripes are painted. The toll booths have since been altered to only collect tolls in the westbound direction, and there are more of them. It was first estimated that the bridge would carry 6 million vehicles and gradually increase to 9 million by the year 1950. Instead, the first year recorded 9 million and in 1950 it was an astonishing 29 million. (Toll Bridge Authority, Alioto collection.)

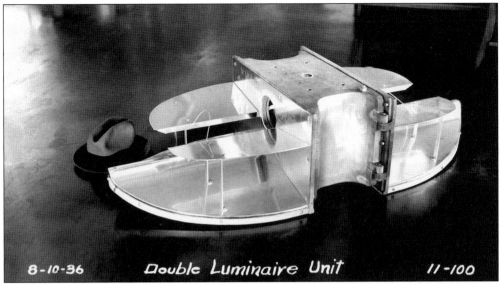

8-10-36　　　Double Luminaire Unit　　　11-100

To provide sufficient lighting on the bridge, even in the densest of bay fogs, these sodium lamps were designed for each one to give off the light of 35 full moons. Few bridge users ever see one of these fixtures, so a closeup photo of one is nice to have. Compare the size of the lamp with that of the man's hat. (Alioto collection.)

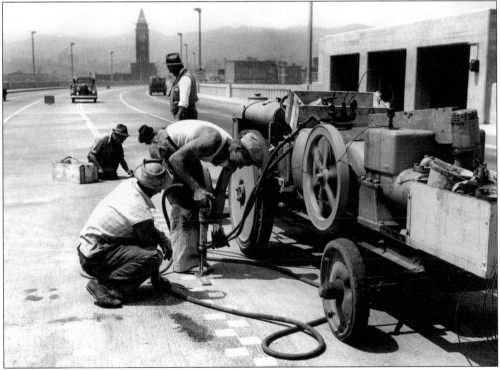

These are some of the 6,500 men who worked to build the Bay Bridge, doing everything from mathematical calculations to riveting, from deep diving to laying cables, from operating boats to pouring concrete, from issuing paychecks to placing the lane markers shown in this photo. (Toll Bridge Authority, Alioto collection.)

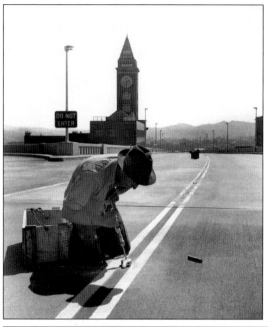

On the San Francisco approach to the bridge, near the Schwabacher-Frey Tower, a workman is installing markers to divide the traffic lanes for east and west. Considering the approach's heavy use today, this scene seems eerie. (Toll Bridge Authority, Alioto collection.)

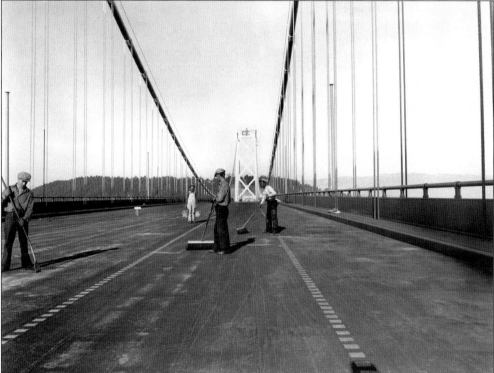

Before automobiles in pre-radial tire days could be expected to drive over the mightiest bridge in the world there was cleanup work to be done, and in the days before mechanical streetsweepers it was left to laborers with pushbrooms to do the work. Meanwhile, the new bridge shines, thanks to 200,000 gallons of silver-grey paint. (Toll Bridge Authority, Alioto collection.)

Five

THE BRIDGE RAILWAY

Before there was BART (Bay Area Rapid Transit District), there was another railway connecting East Bay cities with San Francisco: the Bridge Railway, which was built on the lower deck of the Bay Bridge and used by three privately owned companies. They were the Key System, Sacramento Northern Railway, and the Interurban Electric Railway, which the Southern Pacific formed in 1934 to operate the Red Trains that previously ran under its own name. The Bay Bridge ultimately would serve automobiles, motorcycles, delivery vans, trucks, buses, and trains on two decks over eight miles long—a transportation menagerie worthy of such an impressive structure.

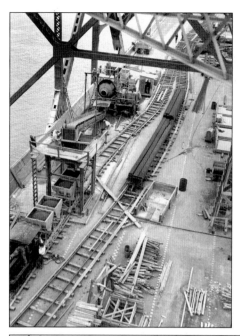

How many railways ran on the San Francisco–Oakland Bay Bridge? The answer is four. The Key System, the Sacramento Northern, the Interurban Electric Railway, and the temporary railway shown here carrying materials for paving the bridge. (Toll Bridge Authority, Alioto collection.)

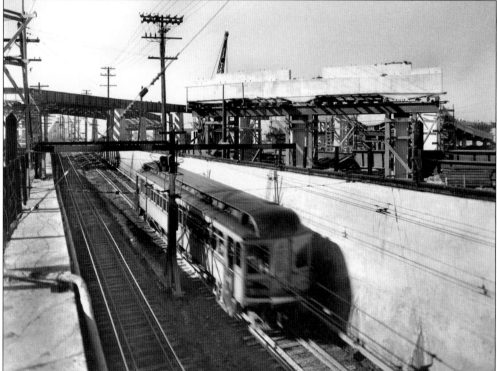

Of the three interurban companies that were to run on the Bay Bridge, the Sacramento Northern and the Key System had to make the fewest adjustments, while the Interurban Electric Railway had to make the most. This is exemplified by this photo showing a Key interurban car dating back to the turn of the century passing out of the so-called Key Subway, which was an underpass under the Southern Pacific's main line. (Toll Bridge Authority, Alioto collection.)

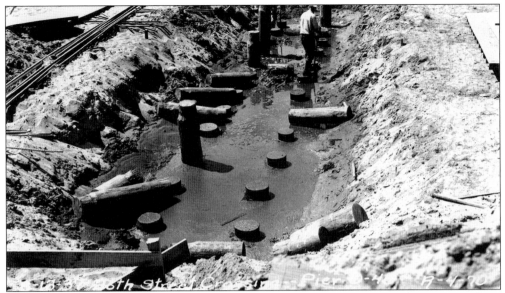

The Southern Pacific routed its Alameda and Oakland Red Trains through the Southern Pacific Sixteenth Street Station and then to the Bridge Railway, necessitating an overpass over its main line. The overpass construction began with pile driving in soggy mudflats, which was no easy task. (Alioto collection.)

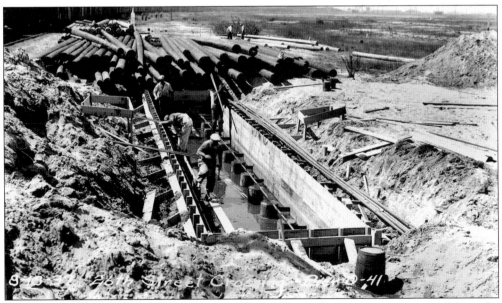

After the piles were driven, a concrete box had to be built, even as water seeped into the structure. (Alioto collection.)

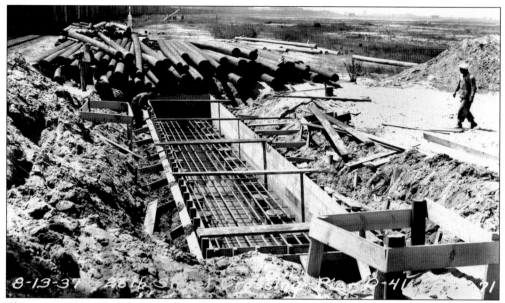

The next stage was to set a mesh of steel rods to reinforce the concrete in the pier. (Alioto collection.)

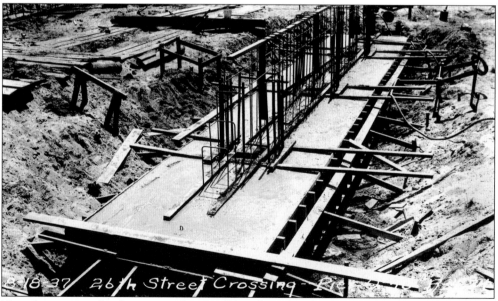

Now the concrete has been poured and will be allowed to harden and settle. The rods on top will reinforce the concrete in the rest of the structure. (Alioto collection.)

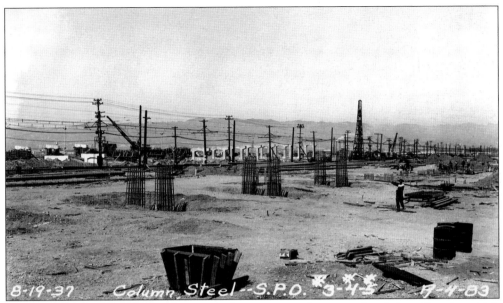

Rising from the foundations shown in the previous photo are banded steel rods, which will anchor the still-to-be-poured concrete columns supporting the new railroad overpass. (Alioto collection.)

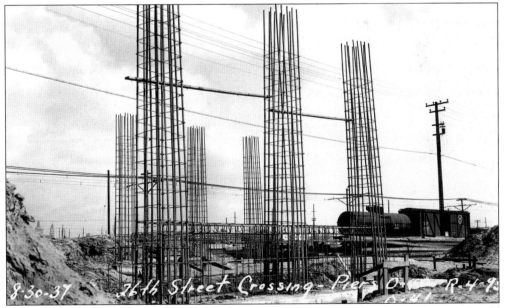

The steel rods for reinforcing the concrete rise higher in this photo while in the background Southern Pacific boxcar No. 20227 and Southern Pacific tanker No. 49154 deliver supplies to the building site. (Alioto collection.)

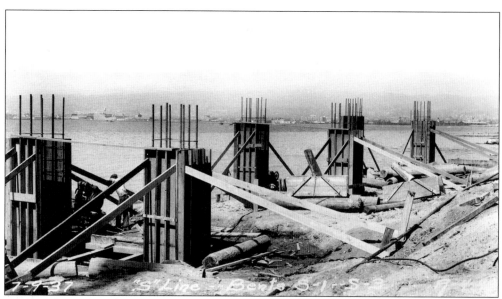

Next, wood molds are built around the steel rods for concrete to be poured into them. (Alioto collection.)

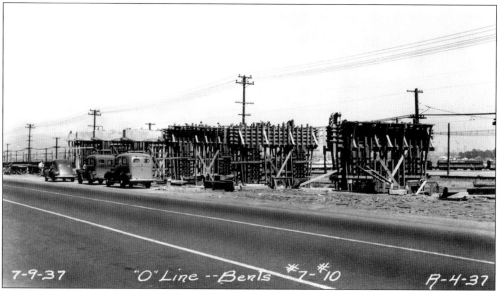

As work on this job is complete, we note the photo is dated July 9, 1937, a full eight months after the Bay Bridge had opened for vehicular traffic. By the time the Bridge Railway opened a year and a half later, potential Bridge Railway patrons had become accustomed to using their automobiles. (Alioto collection.)

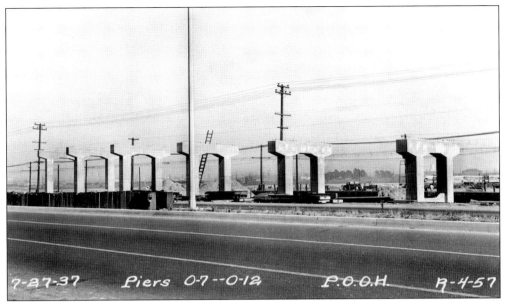

7-27-37 Piers 0-7--0-12 P.O.O.H. R-4-57

With their molds stripped off, the new piers for the Twenty-sixth Street overpass for the Interurban Electric Railway have a plain but stately look. (Alioto collection.)

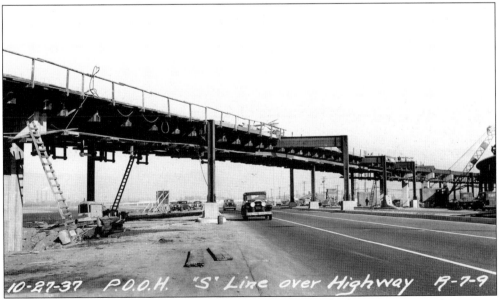

10-27-37 P.O.O.H. "S" Line over Highway R-7-9

All of the approaches, whether for rail transit or automobiles, had to go over or under existing rights of way that had to be kept operable during construction. (Alioto collection.)

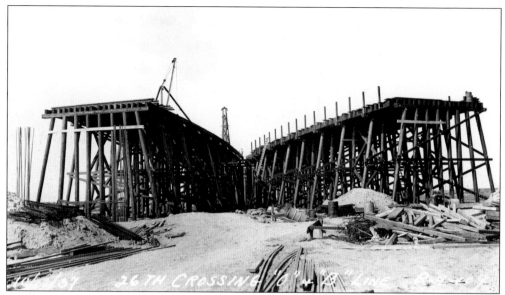

Oakland- and Alameda-bound Red Trains would leave the Bridge Railway yards and go left, in this photo, to the Sixteenth Street Station, while Berkeley-bound trains went to the right, or north. This structure would be called Twenty-Sixth Street Junction because of the location. (Alioto collection.)

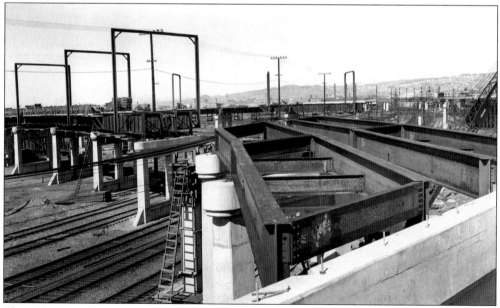

This top view of the Twenty-Sixth Street Junction under construction shows the curve to the south that will bring the Red Trains to and from Oakland's Sixteenth Street Station. In the center background is the north curve for the Berkeley lines. (Alioto collection.)

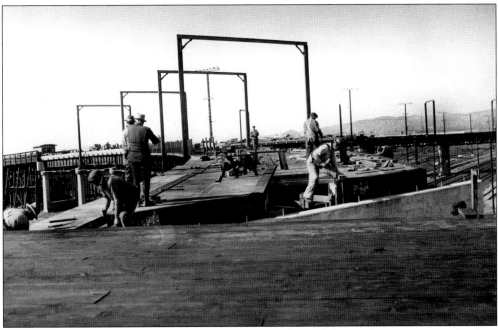

With all the steel and concrete being used, it may seem out of place to have carpenters working on the Twenty-sixth Street Junction, but here they are, building the plank bed for the Interurban Electric Railway's tracks. Note at left how the concrete piers yield to a wooden trestle. (Toll Bridge Authority, Alioto collection.)

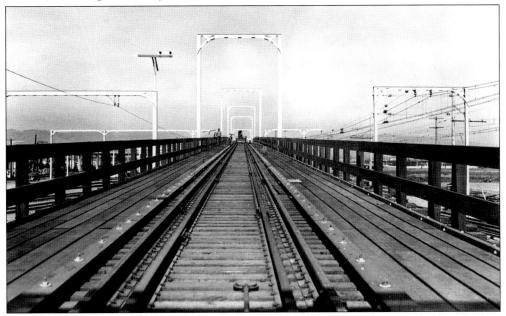

The Interurban Electric Railway trains entered the Bridge Railway via the Interurban Electric Railway Flyover in order not to interfere with either the Key System or the Sacramento Northern and their 600-volt catenary. Once the Key System trains went on to the 600-volt third rail, both the Sacramento Northern and the Interurban Electric Railway used the overhead catenary at 1,200 volts. (Toll Bridge Authority, Alioto collection.)

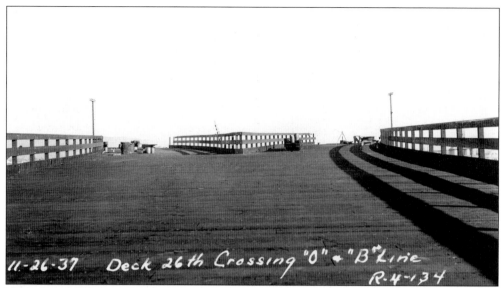

Now that the Twenty-Sixth Street Junction had been decked over, the next step was to create a roadbed and lay the ties and rails to create the tracks. (Toll Bridge Authority, Alioto collection.)

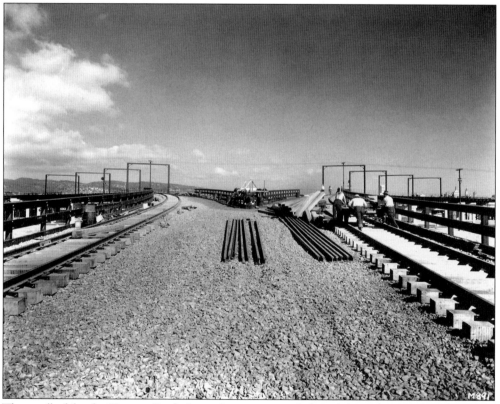

The roadbed for the Twenty-Sixth Street Junction is graded, and the rails are spiked down and have to be ballasted. This work was paid for by the State of California, not the railroad, and was the least complicated of several submitted plans. (Toll Bridge Authority, Alioto collection.)

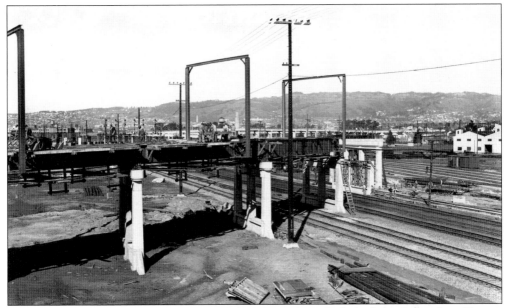

When the job was done, this portion of the elevated tracks linked the Interurban Electric Railway trains to and from Berkeley with the trains arriving from Oakland's Sixteenth Street Station. It was at this point that the Interurban Electric Railway trains entered or left automatic train control territory. (Alioto collection.)

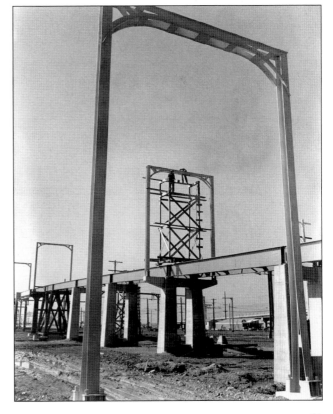

The system for feeding electric power to the three interurban railways using the bridge was first class throughout. These steel gantries that supported the catenary wires were very substantial and were meant to last, but unfortunately they would only be needed for 31 months. (Toll Bridge Authority, Alioto collection.)

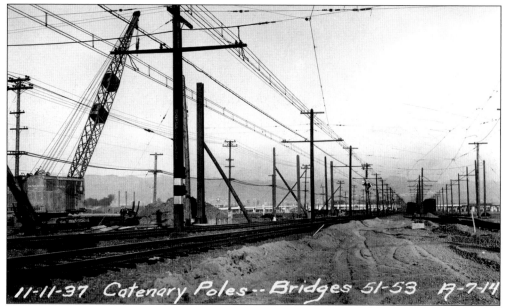

The system of overhead wires and the third rail that fed electric power to the trains was probably as complicated as it looks, especially to one who is neither an electrician nor an electrical engineer. When finished, it would rank as a great project in itself. (Toll Bridge Authority, Alioto collection.)

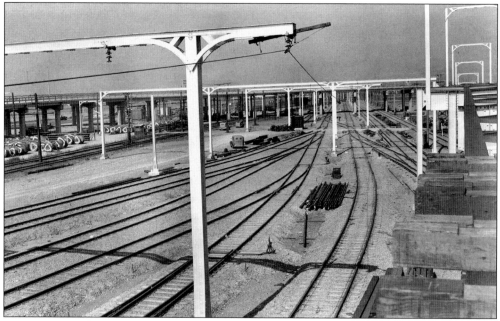

This photo, taken from the unfinished Interurban Electric Railway Flyover, shows that much of the trackwork is done, but interurbans run by electricity and the overhead wires have yet to be installed. (Toll Bridge Authority, Alioto collection).

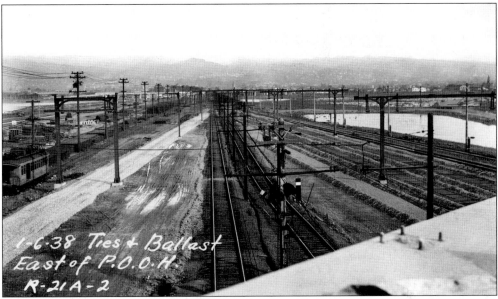

Looking east, we see not only a new roadbed but also ballast gravel and overhead gantries for the catenary wires. At the left is the Key System's overhead line car No. 1201, built in 1895 and presently residing at the Western Railway Museum in Solano County, California. (Alioto collection.)

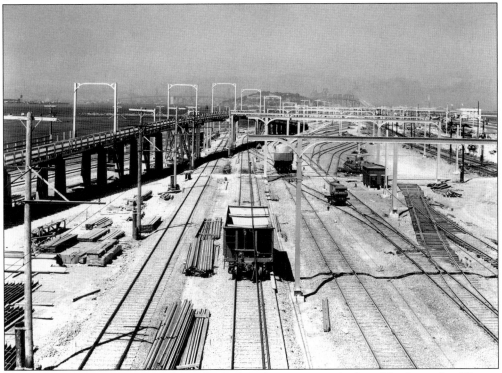

In this view looking west, we see the Bridge Railway beginning to take form. The Interurban Electric Railway Flyover at left is nearing completion, rails are being laid for the storage yards, and gantries have been erected to support the overhead wires. (Toll Bridge Authority, Alioto collection.)

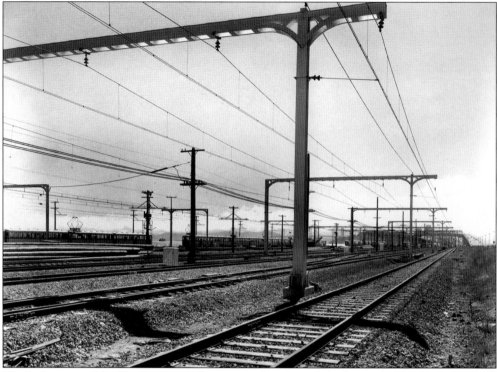

The bridge units of the Key System are photographed on the rails leading to the Key's ferry terminal. When entering the Bridge Railway the Key System will use the pantographs into the yards and then switch over to a third rail for electric power. (Toll Bridge Authority, Alioto collection.)

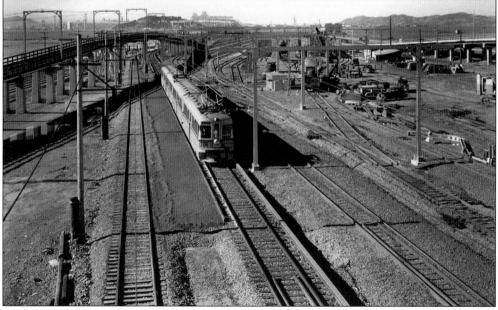

With Bridge Unit No. 147 at the rear, a Key System train heads toward the Key Pier after a trip from Berkeley's Claremont Hotel, delivering passengers to the ferries that, in less than a week, became redundant. (Toll Bridge Authority, Alioto collection.)

Miles of electrical conduit were needed on the Bridge Railway. There were feeder cables bringing power to the overhead catenary and the third rail. There were cables to provide power for the signaling system, for the train control system, the lights, and maintenance buildings. (Toll Bridge Authority, Alioto collection.)

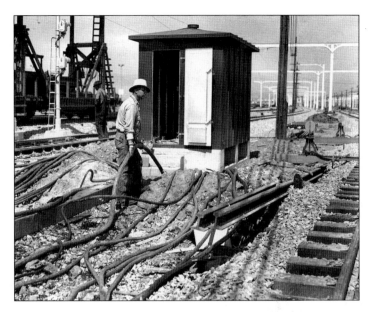

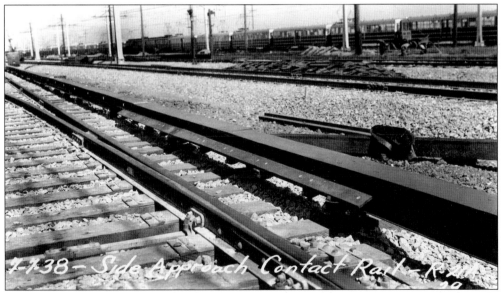

The Sacramento Northern Railway and the Interurban Electric Railway used the overhead wire that was energized at 1,200 volts, while the Key System used the outside third rail at 600 volts. Tripper arms on the roofs of the units made an electrical contact that automatically raised or lowered the pantographs and the third rail shoes. (Alioto collection.)

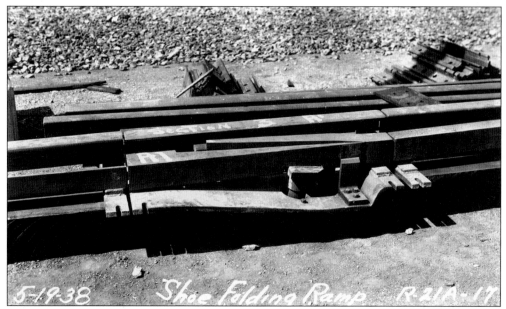

The Key System's contact shoes rode over a folding ramp that automatically elevated the shoes as the pantograph was being raised to make contact with the overhead trolley wires. (Alioto collection.)

During the transition from the older wooden interurbans to the new bridge units, the Key System had a storage space problem. Although the Bridge Railway would not open for another year, it is apparent that some units are already stored in the Bridge Railway yards. The Interurban Electric Railway and the Sacramento Northern did not order new equipment and the Sacramento Northern continued to use its old storage facilities in Oakland. (Alioto collection.)

With less than 10 weeks to go before the opening of the Bridge Railway, the gantries are supporting the catenary wires on the approach across the Oakland mud flats. (Alioto collection.)

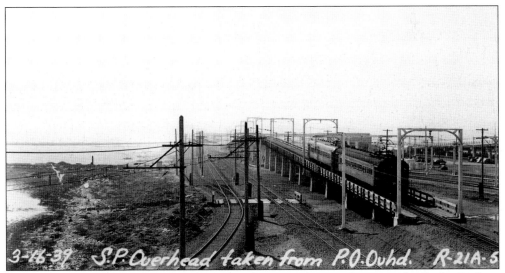

A pair of cars from the Interurban Electric Railway test the new flyover in the Bridge Railway yards. Experience among the trainmen meant little here, for everyone had to learn a new track system as well as the new automatic train control system. (Alioto collection.)

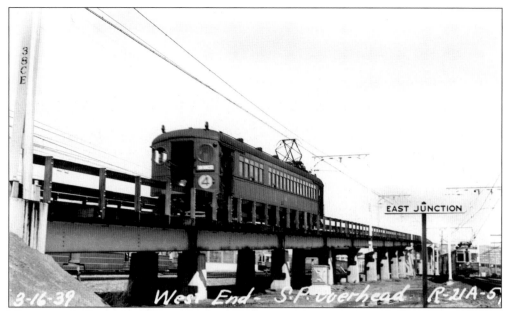

The car on the Interurban Electric Railway Flyover is running empty, probably training another crew. Trainmen on the Interurban Electric Railway were part of Southern Pacific's Western Division and bid by seniority for runs in the division. They had standard railroad union contracts, were paid accordingly, and the motormen were called engineers, just as on steam locomotives. (Alioto collection.)

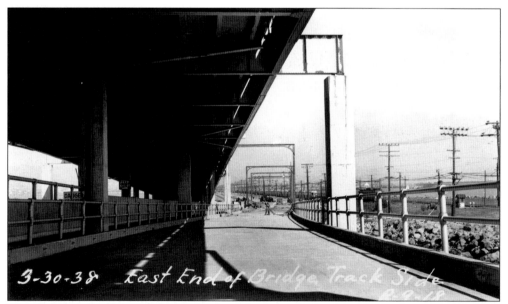

The Bridge Railway was on the south side of the lower deck of the Bay Bridge, and this photo shows how the trains will enter and exit the bridge—once the rails and electrical systems are in place, of course. (Alioto collection.)

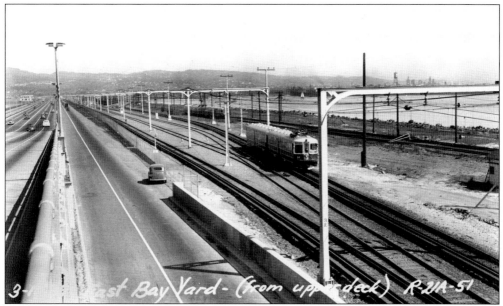

A bridge unit of the Key System is testing the new Bridge Railway with its pantograph down, an indicator that the outside third rail is energized at the proper rating of 600 volts. (Alioto collection.)

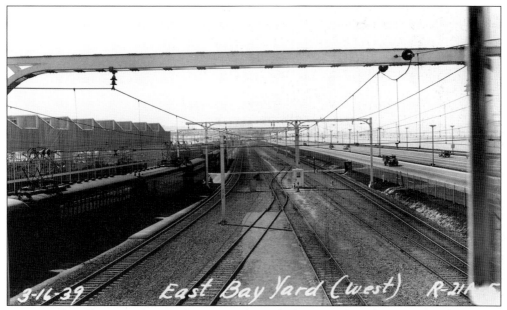

An Interurban Electric Railway Red Train sits alongside the Interurban Electric Railway inspection building. Note how the steel gantry is insulated from electric contact, a good idea in case someone accidentally bumps into the gantry when the power is activated. (Alioto collection.)

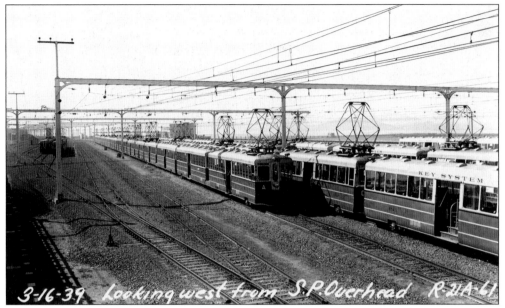

The Key System built 88 of these units for transbay service. A careful look shows that not all were exactly the same. In the lead at center, No. 108 had straight sides and narrow side windows. At right, No. 174 was one of 23 units built by Bethlehem Steel in Wilmington, Delaware, in 1936 and 1937. They were the first to go into service, allowing the Key System to dismantle the older cars and salvage components to be used in some of the "new" units, such as No. 108. (Alioto collection.)

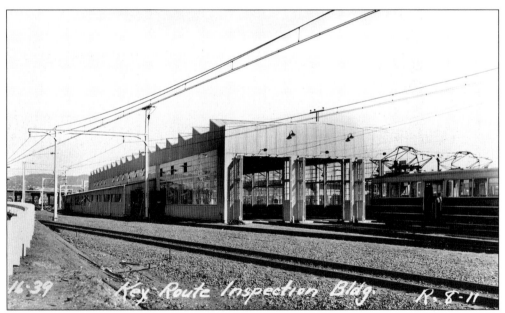

The State of California erected inspection buildings for the interurban companies in the Bridge Railway yard. This building remained a familiar sight to transbay motorists long after the trains vanished into history. (Alioto collection.)

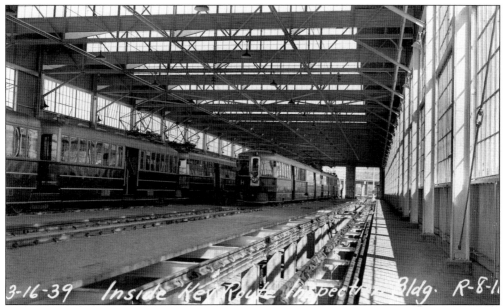

The Key System inspection building was spacious and had plenty of natural light. The pits under the tracks allowed the Key's shopmen access to the underbody components and trucks of the units. (Alioto collection.)

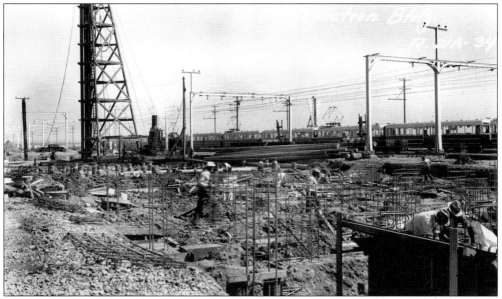

In this photo construction has begun on the Interurban Electric Railway inspection building. Prior to bridge operations all of the servicing of the Red Trains was done at the Southern Pacific's West Alameda Shops, which were not readily accessible to the Bridge Railway. (Alioto collection.)

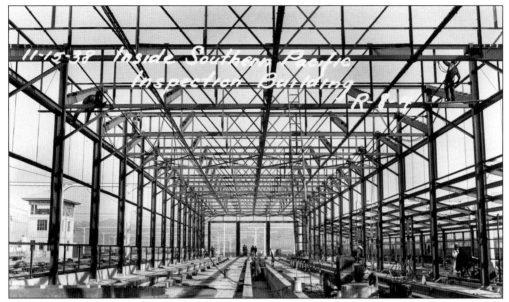

The concrete pits are in place while steelworkers are creating the framework for the Interurban Electric Railway inspection building. Since 1934 the Red Trains were part of the Interurban Electric Railway but entirely Southern Pacific owned and still called the Southern Pacific trains. (Alioto collection.)

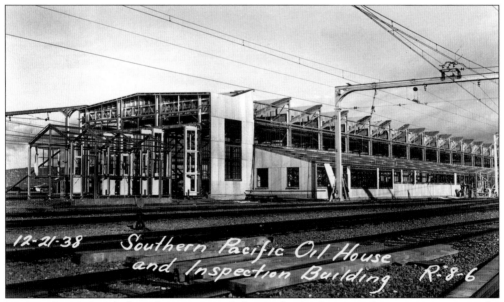

With only 25 days before the opening of the Bridge Railway, work is progressing on the Interurban Electric Railway inspection building. At the east end the oil house is being erected. (Alioto collection.)

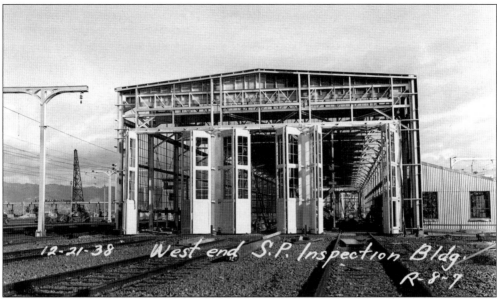

The huge doors of the Interurban Electric Railway inspection building, located slightly west of the toll plaza, are installed, but the amount of work being done to the building shows it was far from complete. (Alioto collection.)

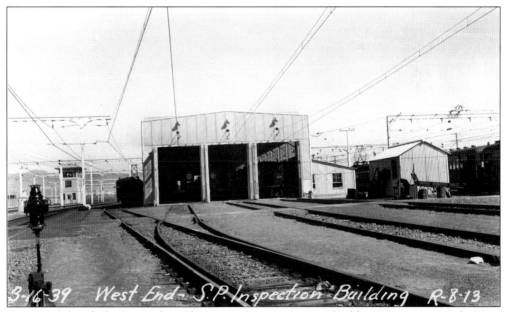

Once completed, the Interurban Electric Railway inspection building was put to good use, as three Interurban Electric Railway cars are seen occupying the service tracks. In spite of losing money on the Red Trains, the Southern Pacific kept the equipment in good shape, and after abandonment many of them found new life on other railroads. (Alioto collection.)

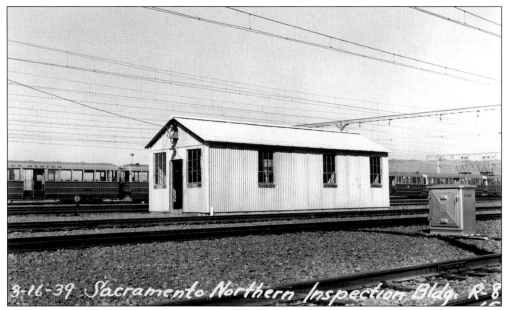

3-16-39 Sacramento Northern Inspection Bldg. R-8

The Sacramento Northern's inspection building was a mere shed, and maintenance work remained at its shops at Fortieth Street and Shafter Avenue in Oakland. By now Sacramento Northern's passenger operations were swimming in red ink and it was questionable how long they would last. In fact, the San Francisco–Sacramento trains were abandoned on August 26, 1940, after only 20 months on the Bay Bridge. (Alioto collection.)

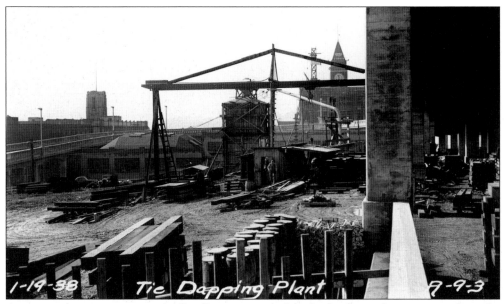

1-19-38 Tie Dapping Plant 9-9-3

An entire plant was set up on the San Francisco end of the bridge for tie dapping, or making the ties ready for true alignment. Some 105,000 crossties were used for the 32 miles of Bridge Railway tracks, with 50,000 of them for the bridge alone. (Alioto collection.)

94

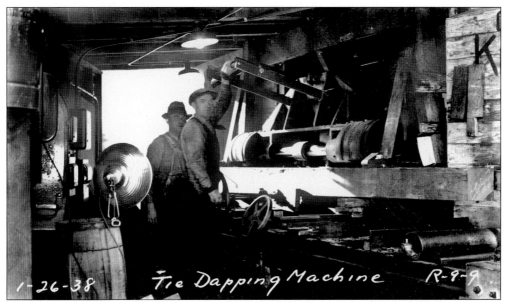

Inside this poorly lit shed was the tie-dapping machine. As the workman pulled down the bar, the machine routed the notches in the ties. (Alioto collection.)

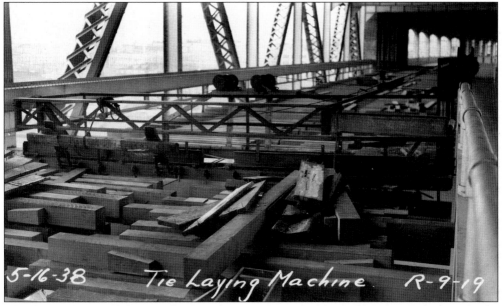

The sheer volume of labor involved to place 105,000 crossties mandated a machine to do the work, hence why this tie laying machine spread the crossties for the railway. The first ties were laid from the Oakland end of the bridge on November 29, 1937. (Alioto collection.)

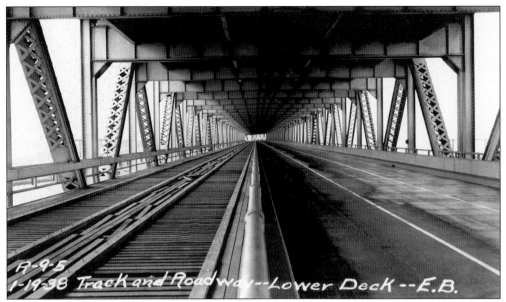

In this photo, taken January 19, 1938, the ties are secured to the bridge and ready for the next process of laying and spiking down the rails. (Alioto collection.)

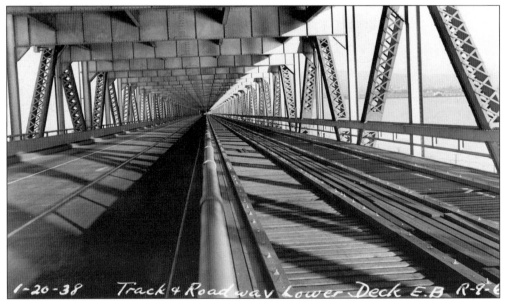

Facing east, we not only catch a glimpse of the crossties in proper alignment, but also the traffic lanes for trucks and buses on the lower deck of the Bay Bridge—one lane each way and a center lane for passing. (Alioto collection.)

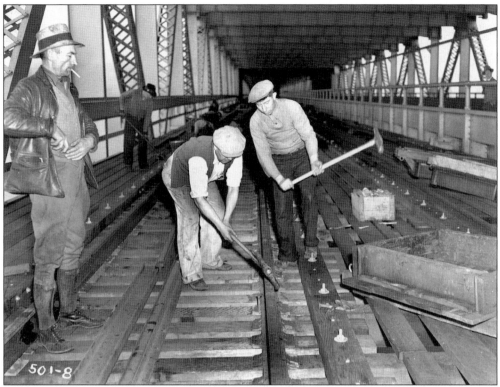

Some of the rail was hand spiked, as this photo proves. Here a foreman pauses to light a cigarette while a pair of laborers swing their mauls, much like John Henry of railroad legend. (Toll Bridge Authority, Alioto collection.)

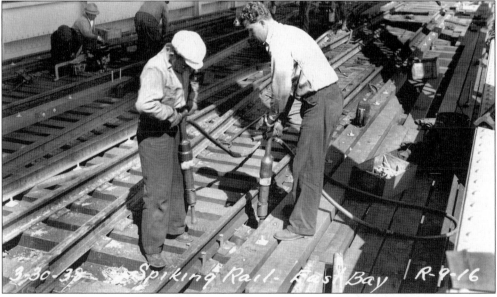

Most of the rails were spiked down using pneumatic hammers. These machines could drive a spike into the crosstie in about three to five seconds. The hard part was lifting the hammer to the next spikehead. (Alioto collection.)

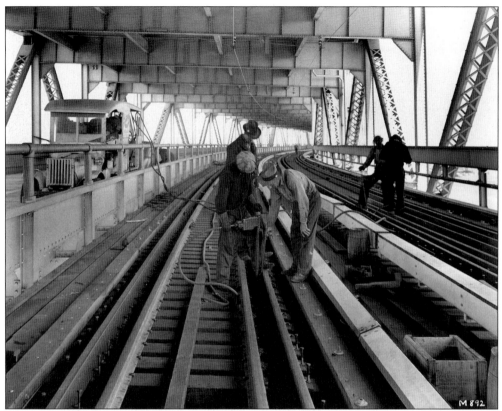

Here the workmen insert lagbolts to secure the plates upon which the rails are spiked down to the crossties. As with the rest of the bridge, this railway construction was first class in every respect. (Toll Bridge Authority, Alioto collection.)

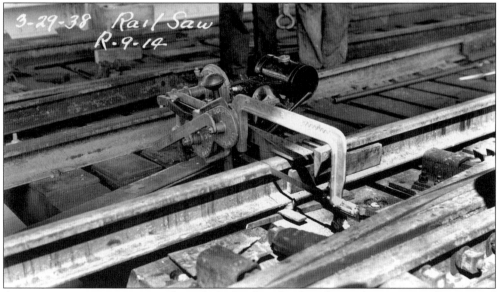

At times it was necessary to saw through the hard steel rail, and in such a case a small motorized rail saw was used. (Alioto collection.)

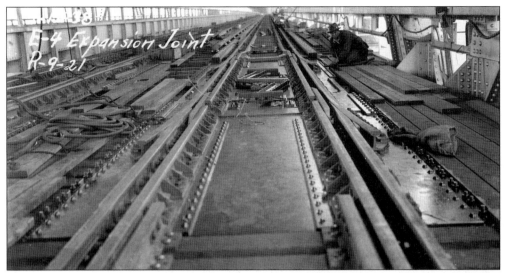

Steel expands with heat, even warmth from the sun. Therefore expansion joints were installed for expansion or contraction of the rails. A railway on a suspension bridge creates further problems to solve as the bridge is apt to sway in high winds. When finished, the Bridge Railway was an engineering marvel in its own right. (Alioto collection.)

Looking toward Beale Street in San Francisco's South of Market District, work is underway for the Transbay Terminal where the trains will arrive and depart. A question that arises is how did those men get up there without ladders? (Alioto collection.)

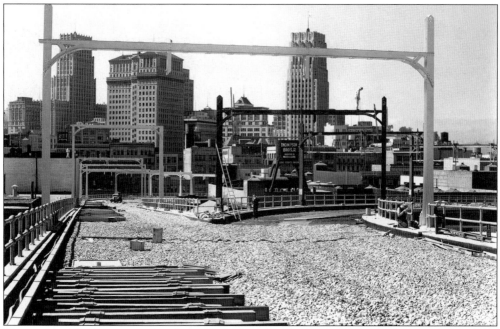

Heavy gravel has been spread and some crossties placed in preparation for the tracks in and out of the Transbay Terminal. Trains going westbound into the terminal will go to the right and return east on the left. (Toll Bridge Authority, Alioto collection.)

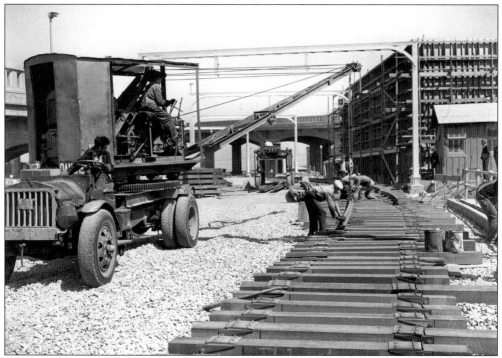

"Set 'er down easy, boys!" Even with help from the crane mounted on this Federal truck with a hand-crank starter, strong bodies were still a prerequisite for railroad building. (Toll Bridge Authority, Alioto collection.)

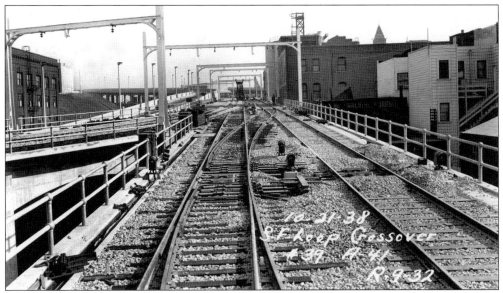

On the section of the loop leading from the Transbay Terminal a crossover switch has been installed to allow trains to switch from one track to another. This view is facing east, and at the left is the ramp leading to the terminal itself. (Alioto collection.)

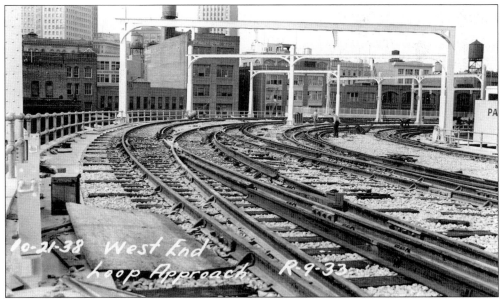

A maze of switches will lead westbound trains from a single track on the bridge into one of six tracks inside the terminal, with Track 1 at left and Track 6 at the far right. Track 6 was reserved for the Sacramento Northern Railway. (Alioto collection.)

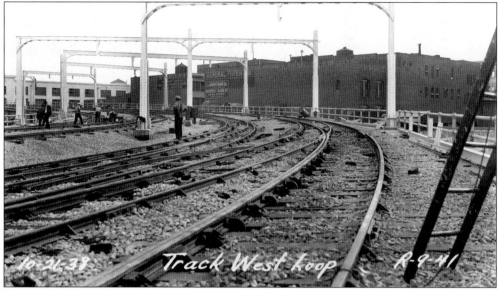

Although finishing touches are being applied to the tracks, the overhead catenary has yet to be installed. (Alioto collection.)

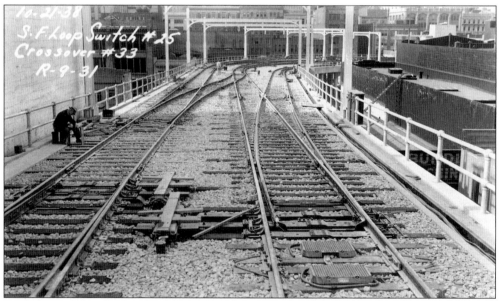

Looking north we see how six tracks inside the Transbay Terminal have become three, and then two on the loop leading back to the bridge. Soon it will be single track all the way to Oakland. (Alioto collection.)

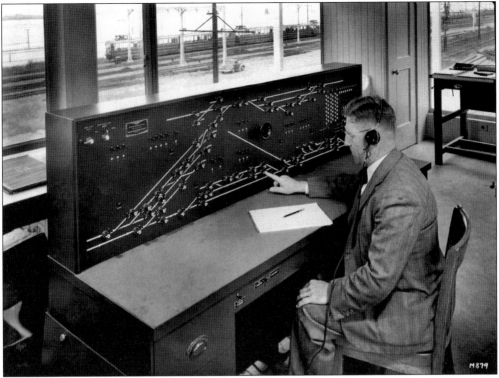

On January 7, 1939, Southern Pacific signal inspector Gus Clark was photographed testing the NX System in the control tower in the Bridge Railway yard. This board controlled all train movements in and out of the storage yards. NX stood for eNtrance and eXit. At peak times with all three railways running, two dispatchers were needed. (Toll Bridge Authority, Trimble collection.)

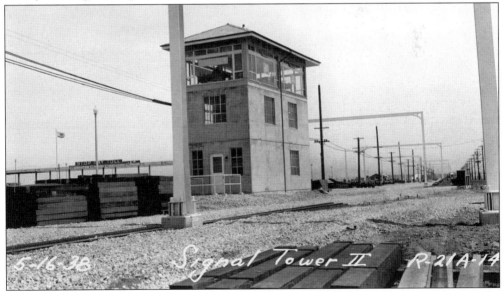

From the control tower in the yard, signals will be sent to the Transbay Terminal, informing the NX operator of oncoming trains so that the switches can be set and the trains properly routed. (Alioto collection.)

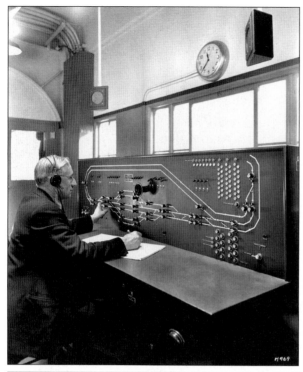

Inside the Transbay Terminal the towerman controlled the movements of all trains on the Bridge Railway. Each line indicated a track, and the lights indicate a train's location. The NX System, by General Railway Signal Co., could control as many as 1,000 trains a day. The Bridge Railway itself was designed to move one train every 63½ seconds and 17,000 people in or out of San Francisco every 20 minutes. (Toll Bridge Authority, Alioto collection.)

In the southeast corner of the Transbay Terminal a towerman is able, by flipping toggle switches, to light various indicator signs around the terminal that explained if each train, on each railway, and on each track was either arriving or departing. (Toll Bridge Authority, Trimble collection.)

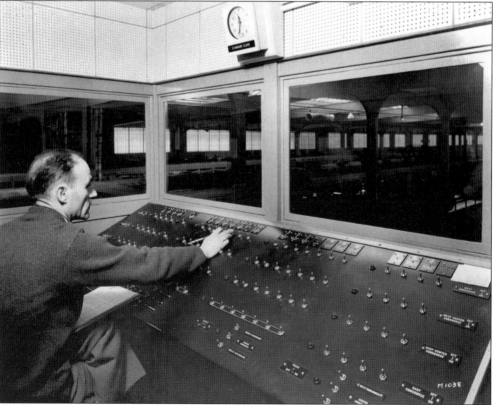

A Key System motorman has his right hand on the controller, regulating the power to the motors. Under his palm is the "dead man" knob that must be held down while the car is moving or else the brakes will go into emergency stop. The box at his left will light one of four numbers and colors, indicating permissible speeds of either 11, 17, 25, or 35 mph. "NS," when lit, indicates the train is on non-signaled trackage. The white light indicates the train is moving at the maximum permissible speed. At the top, a bell warns if the train is going faster than allowed, and if speed is not reduced within 1½ seconds emergency brakes will apply. General Railway Signal Co. installed this system for $1.4 million. (Haas-Schreiner photo, Toll Bridge Authority, Trimble collection.)

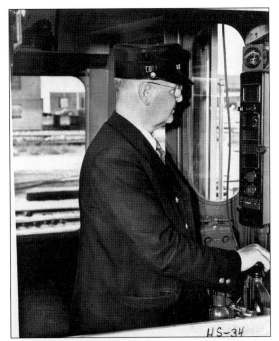

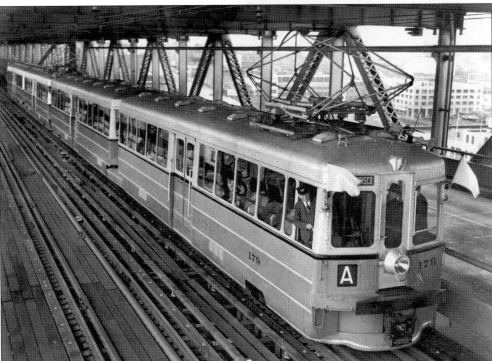

On September 24, 1938, a Key System test train ran on the bridge. Wearing a motorman's cap and piloting the train was Gov. Frank Merriam. Sharp-eyed readers will notice the governor is in the rear motorman's cab, the train is westbound, and the seats face west, meaning it is a posed photo. The pantograph is up because the overhead was energized at 600 volts for this run. (Toll Bridge Authority, Trimble collection.)

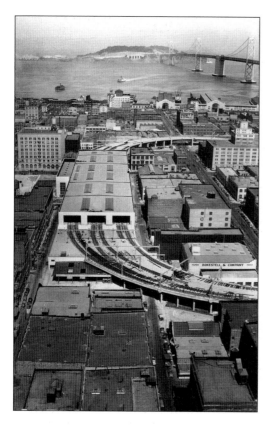

This aerial view shows the trackwork under construction for the Transbay Terminal, with a pair of ferries heading for the Ferry Building. Treasure Island is getting ready for the World's Fair and the majestic bridge. The center anchor between the two spans is larger than the biggest pyramid in Egypt—if you include the underwater portion. (Toll Bridge Authority, Alioto collection.)

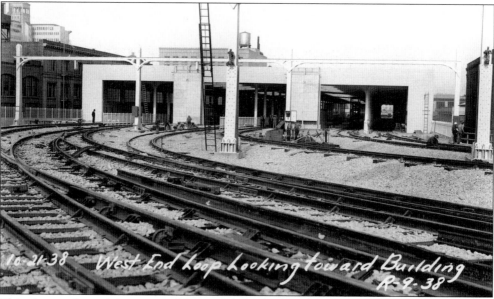

This closeup shot of the west-end loop of the Transbay Terminal, taken October 21, 1938, shows the six tracks emerging from the unfinished terminal and without the overhead catenary. (Alioto collection.)

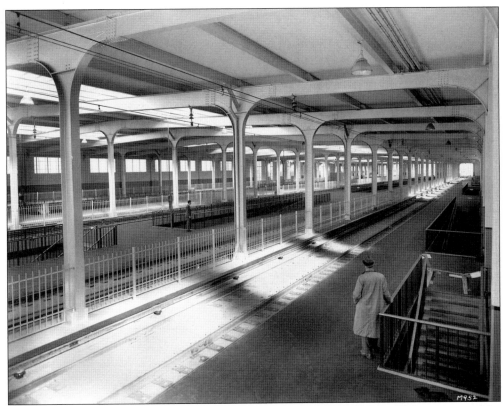

With only two men and no trains or activity going on, this late 1938 view of the interior of the Transbay Terminal has a surreal look, a far cry from the photos on page 109. (Toll Bridge Authority, Alioto collection.)

The terra cotta stairs and ramp lead from the mezzanine to the top where the trains will arrive and depart. Interestingly, for a modern building with three levels, there were neither elevators nor escalators, and after 40 years of using the two-level Ferry Building many transbay travelers were understandably confused by this complex. (Toll Bridge Authority, Alioto collection.)

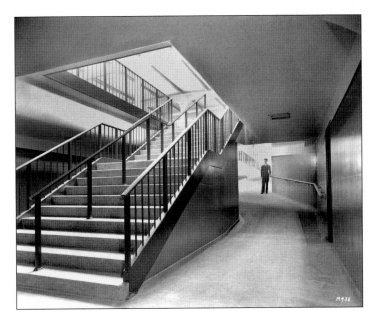

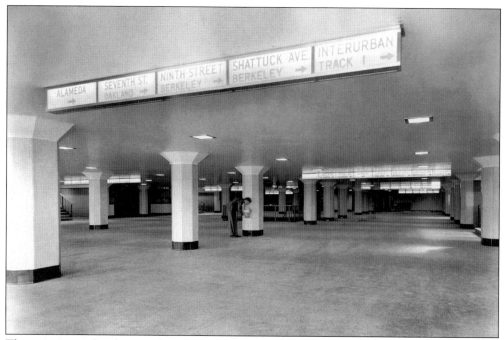

The mezzanine level's signs are lit, telling passengers where to meet their trains, and is controlled by the console shown on page 104. Unfortunately, Interurban Electric Railway and Sacramento Northern patrons never really had a chance to get used to this spacious San Francisco landmark. (Toll Bridge Authority, Alioto collection.)

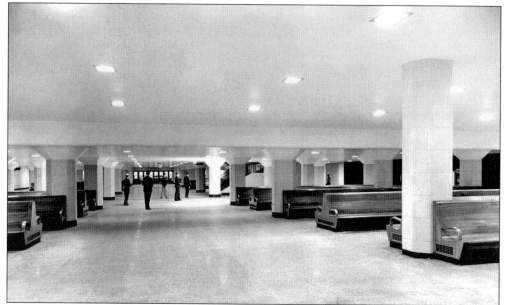

The ground level offered plenty of large benches for waiting, public restrooms, and eating facilities. Because of the two flights of stairs to the trains, this level never reached its potential. During World War II it was often crowded with sailors and marines on liberty returning to the naval base on Treasure Island in various stages of inebriation. In later years it became a place for winos to "sleep it off." (Toll Bridge Authority, Alioto collection.)

This photo was made on January 17, 1939, inside the new Transbay Terminal in San Francisco. Unit No. 182, at left, is signed X, meaning it is a special to the World's Fair. Today, No. 182 is preserved at the Western Railway Museum in Solano County, California. (Toll Bridge Authority, Trimble collection.)

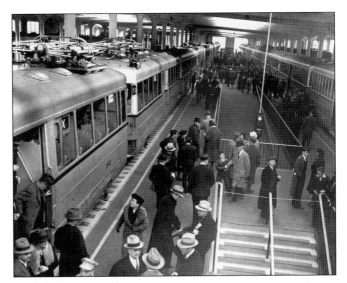

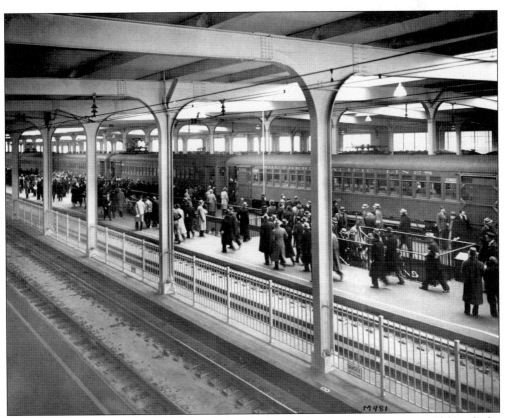

A Red Train from the East Bay has arrived and unloaded hundreds of passengers. Although the trains were crowded the first few days, this was not to last. There were unforeseen technical problems and train engineers hadn't much experience with the train control system, resulting in delays due to emergency stops on the bridge. (Toll Bridge Authority, Trimble collection.)

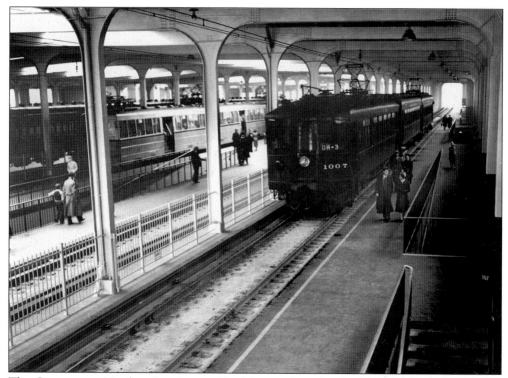

The Sacramento Northern's primary ridership was long haul, although there were a few commuter trains from Contra Costa County. Track 6 was reserved for the Sacramento Northern, with the Interurban Electric Railway and the Key System using Tracks 1–5, at left. (Toll Bridge Authority, Trimble collection.)

OUR REGRETS AND THANKS

TO OUR PATRONS:

We sincerely regret the delays and interruptions in schedules since the inauguration of electric train service over the Bay Bridge, January 15th, and we want you to know that we appreciate the patience and consideration patrons have shown us in the face of these inconveniences to them.

Inauguration of train service over the bridge involved a very radical change in operations with a great many more difficulties to meet and overcome than were involved in the previous operation of these trains when connections were made with the ferries. On the inauguration of the bridge service, problems developed that could not have been foreseen and in addition several failures occurred in mechanism which could not have been anticipated plus several traffic accidents that blocked service on several lines. Thus the service was not only delayed but also trains in the rush hours have been overcrowded.

Everything is being done to the limit of our abilities to remedy the situation. Difficulties are being ironed out, service is improving and we believe that within a few days we will be providing normal service on regular schedules—the kind of service all officers and employes of this company earnestly desire to give.

R. E. HALLAWELL, Manager,
Interurban Electric Railway.

The last thing the money-losing Interurban Electric Railway needed was a further decline in patronage. Thus, R.E. Hallawell, manager of the Interurban Electric Railway, issued these cards of regret to all passengers, pleading for understanding. In fact, the Interurban Electric Railway was already running on borrowed time. (From the late Robert S. Ford, Trimble collection.)

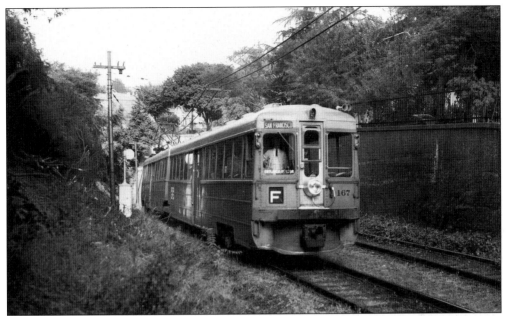

With abandonment of the Interurban Electric Railway's Red Trains in 1941, the Key System assumed some of the Interurban Electric Railway trackage and service. Here Bridge Unit No. 167 has left the old Southern Pacific Northbrae Tunnel en route to Shattuck Avenue, Adeline Street, and over the bridge to the City by the Golden Gate. (Tom Gray photo, Trimble collection.)

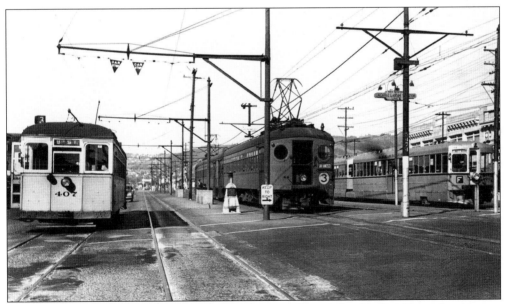

Berkeley's wide Adeline Street hosted six railway tracks: two for the Key System's streetcars at left, two for the Southern Pacific/Interurban Electric Railway trains at center, and another pair for the Key System interurbans. This clearly shows how streetcars were effective feeders for interurban trunk lines, even if they lost money at the farebox. (Roy Covert photo, Trimble collection.)

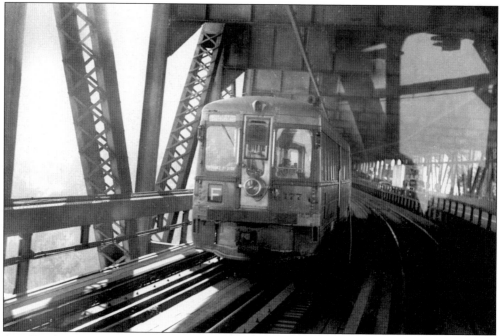

As a Key System F train heads across the bridge to Berkeley at 35 mph, trucks and autos may go 45 mph; a definite handicap that encouraged additional automobile travel instead of "rapid" transit and caused the bonds paying for the bridge to be retired earlier than projected. (From the late Stephen D. Maguire, Trimble collection.)

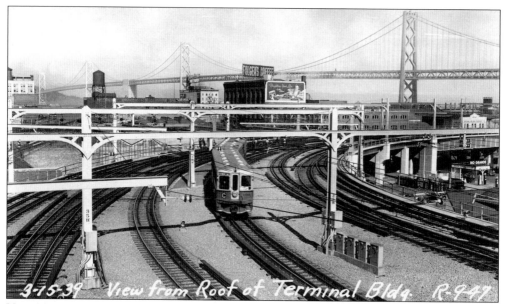

3-15-39 View from Roof of Terminal Bldg. R-947

Unit No. 100 was photographed on March 15, 1939, while about to enter the Transbay Terminal. It was built in the Key's Emeryville Shops using frames and sides from the old 650 Class interurbans. While modern in appearance, the units were underpowered, slow, and many of the recycled components were already obsolete. Old before their time, they were to have been replaced by more modern equipment, but this never came to pass. (Alioto collection.)

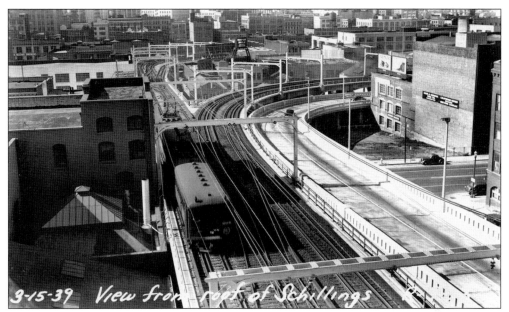

Photographed from the roof of Schilling's spice processing plant, a brace of cars on the Interurban Electric Railway has left the Transbay Terminal and heads eastbound on the 3 train for Shattuck Avenue in Berkeley. After abandonment, 61 of these cars wound up on the Pacific Electric Railway in Southern California, where they were called "blimps" because of their huge size. (Alioto collection.)

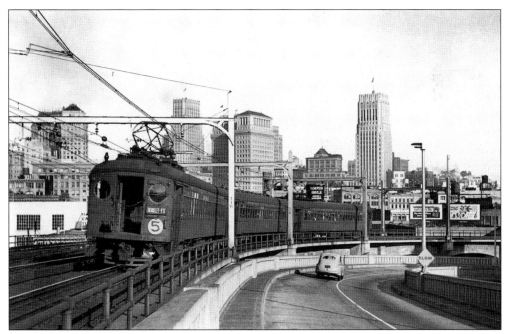

Ken Kidder photographed this three-car train arriving at the loop to the Transbay Terminal in San Francisco. The tall building at right is the 36-story Russ Building, then the city's tallest. (Ken Kidder photo, Trimble collection.)

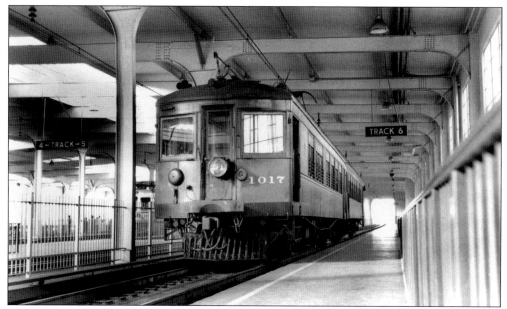

Train 36, headed by Sacramento Northern No. 1017, waits on Track 6 at the Transbay Terminal. The train was a local to West Pittsburg, leaving at 6 p.m. and arriving in West Pittsburg at 7:38 p.m. This photo was taken in 1940; on June 30, 1941, the last Sacramento Northern passenger train departed this terminal. (Trimble collection.)

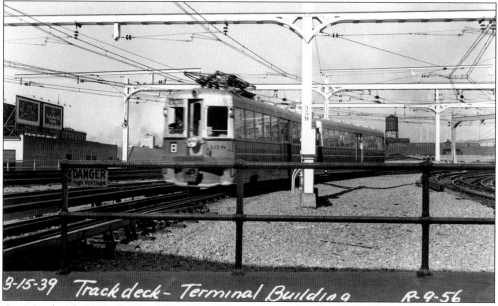

On March 15, 1939, Bridge Unit No. 168 arrives at the Transbay Terminal. The State of California spent $18 million building the Bridge Railway after the three railways declined to pay for it, claiming economic hardship. Instead, they gave title to rolling stock as collateral against a percentage of farebox revenues. Thus Units Nos. 151–187 became state property, including No. 168. (Alioto collection.)

Six

THE GOLDEN
GATE BRIDGE

While planning for the Bay Bridge was going on, six California counties combined to form the Golden Gate Bridge and Highway District in order to finance and build the Golden Gate Bridge, another engineering marvel. Since these two structures opened within a year of each other, and complemented each other in many ways, it seems reasonable to take note of what was happening across the Golden Gate.

A barkentine, escorted by a steam-powered tug, sails through the Golden Gate amidst a flotilla consisting of an ocean-going steamer, fishing smacks, and a coastal schooner at sunset around 1900. When this postcard was made, a bridge across the Golden Gate was out of the question. (Trimble collection.)

This view of where the Golden Gate Bridge would be built was made in April of 1908, 20 years before the formation of the Golden Gate Bridge and Highway District that would design, finance, and construct "the bridge which couldn't be built." Although the water looks placid, it's swirling with ocean tides and is above the notorious San Andreas Fault. (Trimble collection.)

116

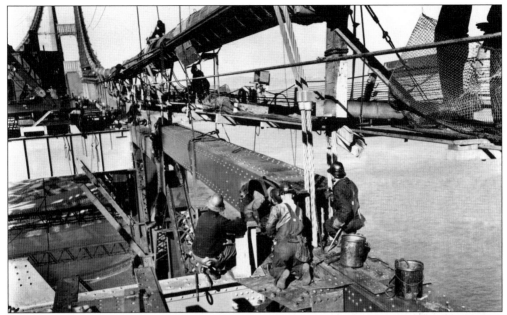

Workmen, 220 feet above the water, position the last 25-foot beam to join the roadway midspan. The date is November 18, 1936, and already the Golden Gate Bridge is becoming a colossus, with the two cables—each 36½ inches in diameter and containing 27,572 wires—being the longest bridge cables ever built at 7,659 feet long. The safety nets were an innovation of Chief Engineer Joseph B. Strauss, who spent $80,000 on them. Some 19 men fell safely into the net, joining the rather exclusive "Halfway to Hell Club." (Trimble collection.)

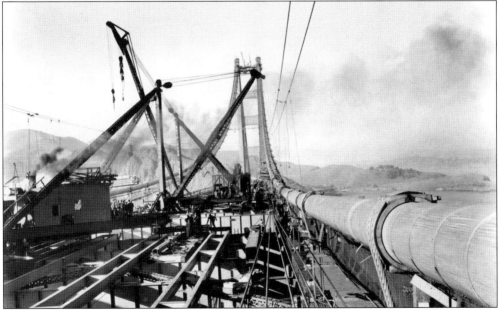

The two traveling derricks that lifted sections of the roadway into place meet at midspan. The North Tower, seen here, was built on land, while the South Tower was constructed on a pier going below the water and into the bedrock. Each cable anchorage was made of more than 30,000 cubic yards of concrete. (Trimble collection.)

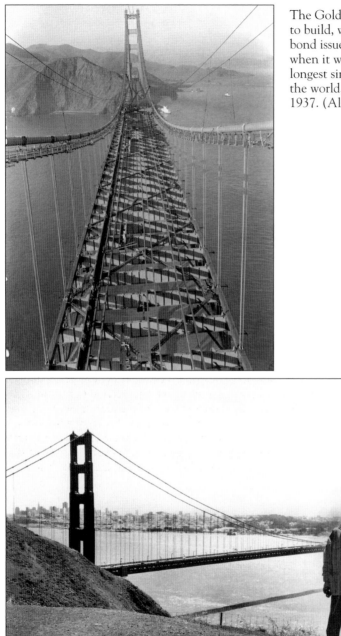

The Golden Gate Bridge took 4½ years to build, was financed by a $35 million bond issue to be repaid from tolls, and when it was completed it was the longest single-span suspension bridge in the world, opening for business May 29, 1937. (Alioto collection.)

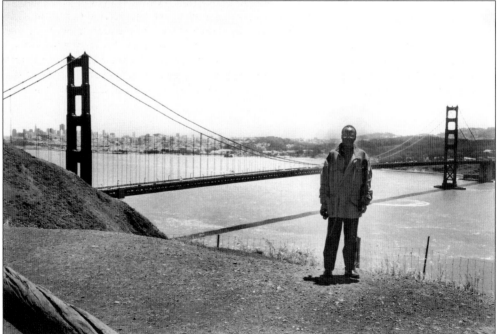

Today, nearly seven decades after opening for traffic, the Golden Gate Bridge is not only a vital traffic artery between San Francisco and Marin County, but a world landmark as well, attracting visitors from every continent, such as the Rev. Athanasius Akunda from Ebukhubi, Kenya. (Paul C. Trimble photo.)

Seven

THE LEGACY
OF THE BRIDGE

It is reasonable to assume that no other regional construction project had such an impact upon the Bay Area, even as the Bay Bridge was being built. Passenger ferries and automobile ferries couldn't compete economically with the bridge and went under as soon as the authorities would allow, and autos and buses traveled across the bridge before the interurban trains and their ultimate fates were sealed. As auto traffic grew, there was a demand for more freeways, and then for a more efficient use of the bridge. As plans were made to convert the bridge to complete motor vehicle use, BART was planned to replace the Bridge Railway.

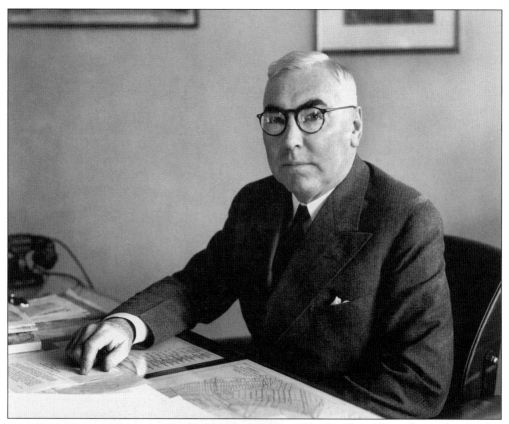

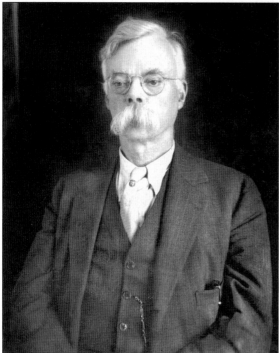

Charles Henry Purcell was the chief engineer whose expertise and ingenuity added up to one word: genius, and the type needed to build the Bay Bridge. It is incredible that two men of the caliber of Charles Purcell and Joseph Strauss were building such monumental bridges not only at the same time, but within a few miles of each other. (Horace Bristol photo, Toll Bridge Authority, Alioto collection.)

Dr. Andrew C. Lawson was a 72-year-old professor emeritus of geology at the University of California, Berkeley, and a renowned authority on local geology. In addition to having mapped the famed San Andreas Fault, Lawson's knowledge of the bay's bottom was invaluable to the building of both the Bay Bridge and the Golden Gate Bridge. (Toll Bridge Authority, Alioto collection.)

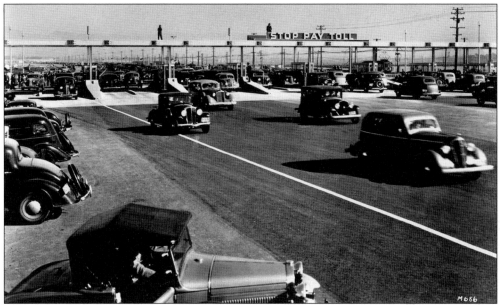

Someone with a discerning eye will note the now vintage cars and the two-way traffic at the bridge toll plaza. Yet one with more hindsight than a discerning eye may quickly dismiss this view of opening day traffic as merely a harbinger of things to come. (Toll Bridge Authority, Alioto collection.)

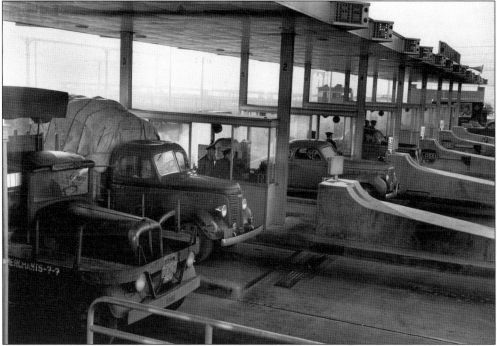

Originally, tolls were charged for both directions on the bridge, and when the volume of traffic demanded an end to the bottleneck, the toll plaza was altered to collect only from westbound motorists. Note also how tolls could be paid from either side of the car. (Toll Bridge Authority, Alioto collection.)

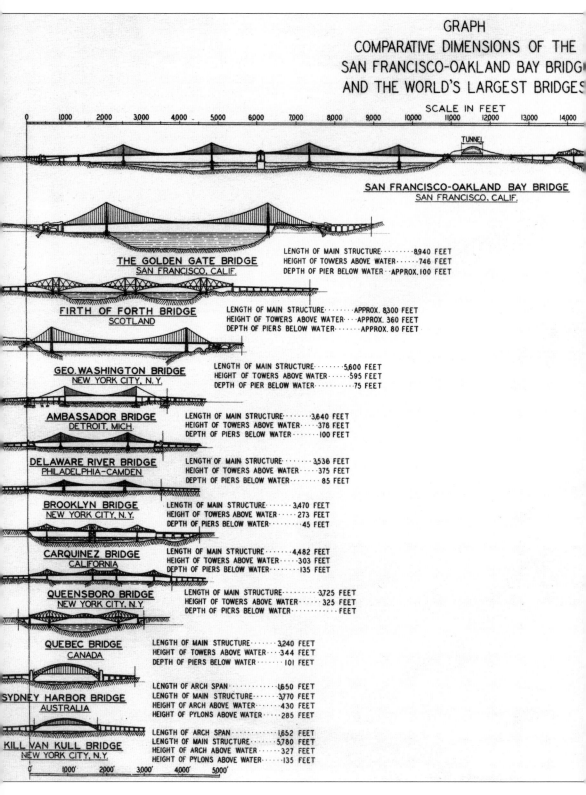

GRAPH
COMPARATIVE DIMENSIONS OF THE SAN FRANCISCO-OAKLAND BAY BRIDGE AND THE WORLD'S LARGEST BRIDGES

SCALE IN FEET

0 1000 2000 3,000 4,000 5,000 6,000 7,000 8,000 9,000 10,000 11,000 12,000 13,000 14,000

TUNNEL

SAN FRANCISCO-OAKLAND BAY BRIDGE
SAN FRANCISCO, CALIF.

THE GOLDEN GATE BRIDGE
SAN FRANCISCO, CALIF.

LENGTH OF MAIN STRUCTURE · · · · · · · · 8,940 FEET
HEIGHT OF TOWERS ABOVE WATER · · · · · · 746 FEET
DEPTH OF PIER BELOW WATER · APPROX. 100 FEET

FIRTH OF FORTH BRIDGE
SCOTLAND

LENGTH OF MAIN STRUCTURE · · · · · · APPROX. 8,300 FEET
HEIGHT OF TOWERS ABOVE WATER · · · · APPROX. 360 FEET
DEPTH OF PIERS BELOW WATER · · · · · · APPROX. 80 FEET

GEO. WASHINGTON BRIDGE
NEW YORK CITY, N. Y.

LENGTH OF MAIN STRUCTURE · · · · · · · 5,600 FEET
HEIGHT OF TOWERS ABOVE WATER · · · · 595 FEET
DEPTH OF PIER BELOW WATER · · · · · · · · 75 FEET

AMBASSADOR BRIDGE
DETROIT, MICH.

LENGTH OF MAIN STRUCTURE · · · · · · · 3,640 FEET
HEIGHT OF TOWERS ABOVE WATER · · · · 378 FEET
DEPTH OF PIERS BELOW WATER · · · · · · 100 FEET

DELAWARE RIVER BRIDGE
PHILADELPHIA–CAMDEN

LENGTH OF MAIN STRUCTURE · · · · · · · 3,536 FEET
HEIGHT OF TOWERS ABOVE WATER · · · · 375 FEET
DEPTH OF PIERS BELOW WATER · · · · · · 85 FEET

BROOKLYN BRIDGE
NEW YORK CITY, N. Y.

LENGTH OF MAIN STRUCTURE · · · · · · · 3,470 FEET
HEIGHT OF TOWERS ABOVE WATER · · · · 273 FEET
DEPTH OF PIERS BELOW WATER · · · · · · · · 45 FEET

CARQUINEZ BRIDGE
CALIFORNIA

LENGTH OF MAIN STRUCTURE · · · · · · 4,482 FEET
HEIGHT OF TOWERS ABOVE WATER · · · · 303 FEET
DEPTH OF PIERS BELOW WATER · · · · · · 135 FEET

QUEENSBORO BRIDGE
NEW YORK CITY, N. Y.

LENGTH OF MAIN STRUCTURE · · · · · · · 3,725 FEET
HEIGHT OF TOWERS ABOVE WATER · · · · 325 FEET
DEPTH OF PIERS BELOW WATER · · · · · · · · FEET

QUEBEC BRIDGE
CANADA

LENGTH OF MAIN STRUCTURE · · · · · · · 3,240 FEET
HEIGHT OF TOWERS ABOVE WATER · · · 344 FEET
DEPTH OF PIERS BELOW WATER · · · · · · 101 FEET

SYDNEY HARBOR BRIDGE
AUSTRALIA

LENGTH OF ARCH SPAN · · · · · · · · · · 1,650 FEET
LENGTH OF MAIN STRUCTURE · · · · · · 3,770 FEET
HEIGHT OF ARCH ABOVE WATER · · · · 430 FEET
HEIGHT OF PYLONS ABOVE WATER · · · 285 FEET

KILL VAN KULL BRIDGE
NEW YORK CITY, N. Y.

LENGTH OF ARCH SPAN · · · · · · · · · · 1,652 FEET
LENGTH OF MAIN STRUCTURE · · · · · · 5,780 FEET
HEIGHT OF ARCH ABOVE WATER · · · · 327 FEET
HEIGHT OF PYLONS ABOVE WATER · · · 135 FEET

0' 1000' 2000' 3000' 4000' 5000'

122

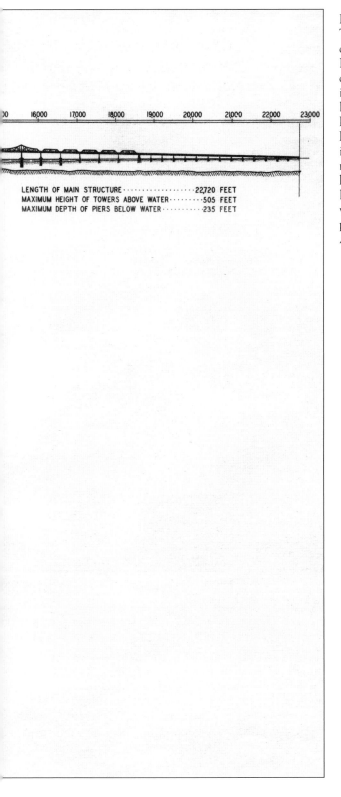

LENGTH OF MAIN STRUCTURE ·22720 FEET
MAXIMUM HEIGHT OF TOWERS ABOVE WATER · · · · · · · · · ·505 FEET
MAXIMUM DEPTH OF PIERS BELOW WATER · · · · · · · · · ·235 FEET

Produced by the State of California Toll Bridge Authority, this graph only begins to tell how the Bay Bridge ranks in proportion to the other great bridges of the world. It is interesting to note that 3 of the 12 listed bridges cross the waters of San Francisco Bay. The double-decked Richmond–San Rafael Bridge, built in 1956, long after this graph was made, is four miles long and would have made this list as one of the two longest high-level bridges in the world. Emperor Norton would be proud. (Toll Bridge Authority, Alioto collection.)

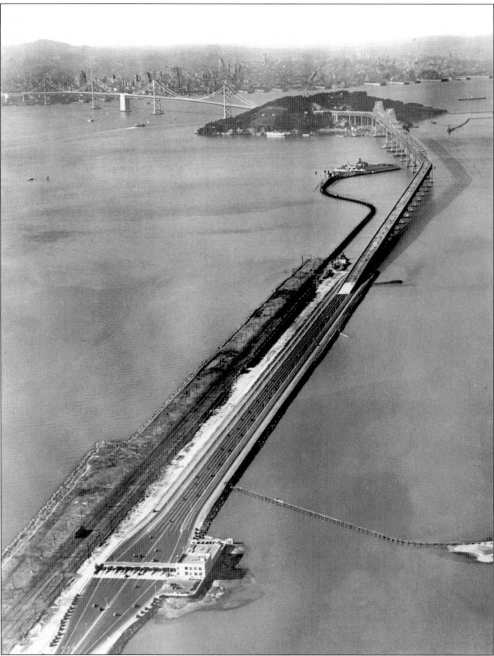

The Bay Bridge, shown shortly after opening to automobile traffic (ending the ferries at the upper left), eventually transformed the Key System's railway trackbed at the lower left into a larger toll plaza, giving impetus to the creation of Treasure Island (upper right, out of photo) for a world's fair and later a U.S. Naval Base, and helped to raise San Francisco's downtown skyline. Today commuter traffic chokes the approaches, BART has replaced part of the Key System, and to avoid the traffic people ride ferries across the bay. (Alioto collection.)

Dressed like a police officer with a Sam Browne belt, a Bay Bridge toll collector is photographed making change for a dollar. Today's drivers pay $3 to cross rather than the 50¢ shown here, and many drivers use FasTrak, an electronic method of recording trips and then charging the driver's credit card account, all unheard of on that rainy day in 1939. (Alioto collection.)

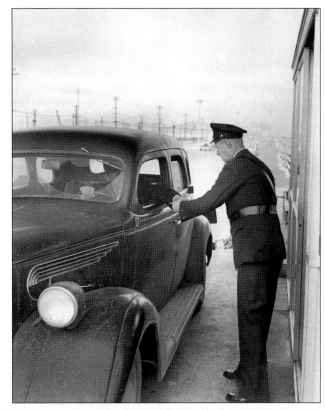

When planned and constructed, this underpass in a quiet Oakland neighborhood was considered sufficient for auto traffic approaching the Bay Bridge. In later years other neighborhoods have been torn asunder by freeways taking vehicular traffic to, from, and around the bridge, with the central portion known to locals as "The Maze." (Toll Bridge Authority, Alioto collection.)

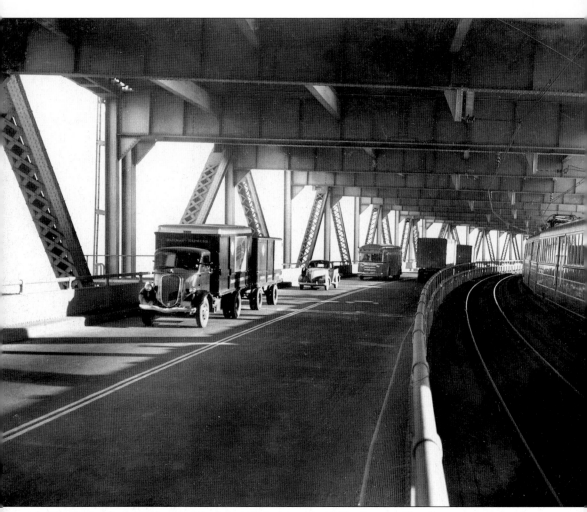

The lower deck of the Bay Bridge on February 14, 1939, shows a Key System train heading toward Oakland, while two lanes are for trucks and buses. The San Francisco–bound Key System bus on the L Route from Richmond is a precursor of things to come, while the early day version of a big-rig truck at left is from the Railway Express Agency, forwarding express parcels from trains. Today the Key System, Railway Express Agency, and two-way traffic on one deck are but memories, while the mighty bridge remains. (Toll Bridge Authority, Alioto collection.)

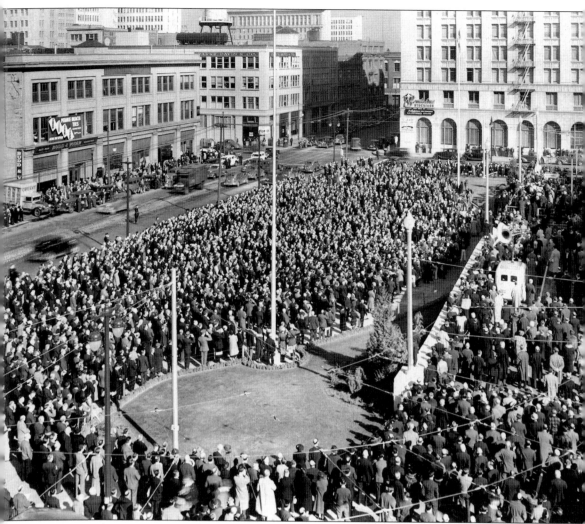

On Saturday, January 14, 1939, the State of California formally dedicated the San Francisco–Oakland Bay Bridge, signaling completion of the project. Three days later the bridge was put to full use as the Bridge Railway opened for service. This view, facing northeast to the intersection of Mission and Fremont Streets in San Francisco, was taken at the raising of the flag as men remove their hats and uniformed police salute. (Toll Bridge Authority, Alioto collection.)

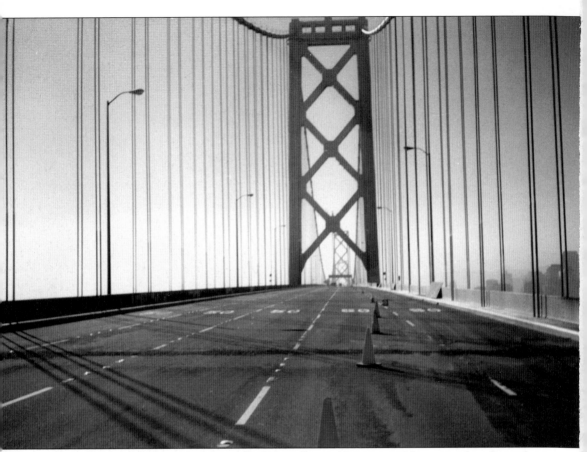

On October 17, 1989, the mightiest bridge in the world was tested by an earthquake with a Richter scale magnitude of 7.0 (equal to 199,000 tons of TNT; the atomic bomb on Hiroshima rated at 20,000 tons of TNT). C.H. Purcell had built it well, for most of the bridge withstood the trembler, although one upper-deck section of the cantilever span collapsed onto the lower deck, shutting it down for days. This photo was taken two days later of the almost totally deserted span. (Deborah Trimble collection.)